IMAGES
of America

WINDSOR LOCKS
CANAL

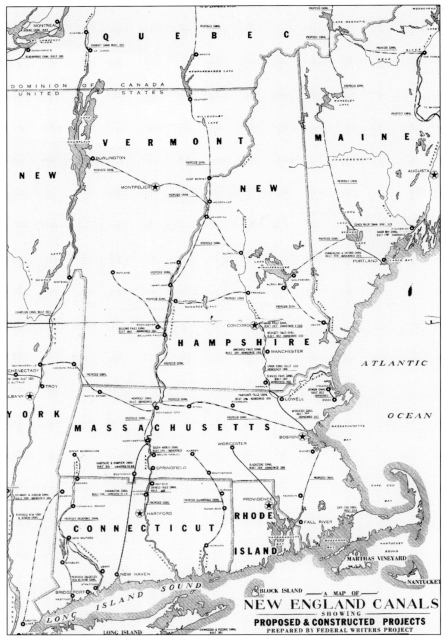

This map of New England canals was prepared by the Federal Writers Project in 1941. During the decades following World War II, the Enfield Falls Canal became known as the Windsor Locks Canal. (Kent Memorial Library.)

On the cover: A boat passes through the lower lock of the Windsor Locks Canal before heading downstream on the Connecticut River in June 1952. (Archives and Special Collections at the Thomas J. Dodd Research Center, University of Connecticut Libraries, Southern New England Telephone Company Records.)

IMAGES
of America

WINDSOR LOCKS
CANAL

Maria Giannuzzi

ARCADIA
PUBLISHING

Published by Arcadia Publishing
Charleston SC, Chicago IL, Portsmouth NH, San Francisco CA

Printed in the United States of America

Library of Congress Catalog Card Number: 2006935852

For all general information contact Arcadia Publishing at:
Telephone 843-853-2070
Fax 843-853-0044
E-mail sales@arcadiapublishing.com
For customer service and orders:
Toll-Free 1-888-313-2665

Visit us on the Internet at www.arcadiapublishing.com

For my father, Frank Giannuzzi, and his stories of the river

CONTENTS

Acknowledgments 6

Introduction 7

1. The River Next Door 9

2. Features and Structures 43

3. Industry along the Canal 57

4. The Canal through the Decades 85

ACKNOWLEDGMENTS

I am very proud to have told the story of the Windsor Locks Canal in this book. Telling that story, however, has been at times an arduous and difficult enterprise, requiring many hours of research and effort. I could not have accomplished this task without the generous assistance of many people. I would like to thank the following individuals who have contributed their time, energy, and knowledge, helping me in this endeavor: Laura Katz Smith at the Thomas J. Dodd Research Center of the University of Connecticut; Lester Smith of the Suffield Historical Society; Maria Rampello; Joseph Grunske of Sticks and Stones Photography; Chet Pohorylo; Vincent Bologna, Anne Marie Kebschull, and the staff of the Library Association of Warehouse Point; Gloria Malek, Eileen Pearce, and the staff of the Windsor Locks Public Library; the staff of the Kent Memorial Library; and the staff of the Enfield Public Library. A special thanks to Dawn Robertson, my editor at Arcadia Publishing, for patiently guiding me through the process of compiling this book.

Many individuals and organizations have generously allowed me to include items from their collections in this book. Among these items are the many photographs and other materials from the Archives and Special Collections at the Thomas J. Dodd Research Center (DRC), University of Connecticut Libraries, including the C. H. Dexter Company Records, Southern New England Telephone Company Records, Leroy Roberts Connecticut Railroad Station Photographs Collection, and the Connecticut Historic Preservation Collection. Other generous contributors include Chet Pohorylo (CP), Maria Rampello (MR), Joseph Grunske (JG), the Suffield Historical Society (SHS), the Kent Memorial Library (KML), the Library Association of Warehouse Point (LAWP), the Enfield Public Library (EPL), the Library of Congress (LC), and the Homer Babbidge Library, University of Connecticut Libraries (HBL).

INTRODUCTION

The story of the Windsor Locks Canal begins at the dawn of the 19th century. In 1800, an industrial society was emerging from America's agrarian roots. In New England, produce and manufactured goods of every description were piled on wharves awaiting shipment to Hartford and Middletown and various points south. The inhabitants of the Connecticut River Valley recognized the importance of the Connecticut River to the future prosperity of the region. A river route would have obvious advantages over the high costs and frequent delays of overland transport.

Sloops, seagoing vessels, could travel upriver as far as Warehouse Point, in the town of East Windsor. Just above Warehouse Point, the fearsome and formidable Enfield Falls was a serious obstacle to boats attempting to go farther north on the Connecticut River. Cargoes were transferred from sloops to flat-bottomed boats called scows at Warehouse Point for delivery to Springfield, Northhampton, and other upriver towns. The scows had to be poled up the falls, a difficult and slow-going method.

In order to get their goods to markets more cheaply and quickly, farmers and merchants supported schemes to construct canals at Enfield Falls and along the upper reaches of the Connecticut River. By 1802, the two smaller canals farther north had been completed. In 1824, a group of prominent Hartford businessmen whose trade with the upriver towns had been placed in jeopardy by the New Haven to Northhampton canal project already under way through Farmington and Southwick formed the Connecticut River Company and devised a plan to build a canal to bypass Enfield Falls. The canal at Enfield Falls would keep the boats, loaded with goods from the north, passing down the river, ensuring the prosperity of the important valley cities of Hartford and Springfield, instead of being turned at Northhampton to the Farmington Canal.

The Connecticut River Company's plan proposed to use steam power to transport goods. Steamboats would be able to safely navigate the whole distance of the river, including the canal at Enfield Falls. Foreseeing that waterpower might be a valuable part of the enterprise, the company also contemplated the building of manufacturing establishments along the canal and designed the canal for the purpose of obtaining power as well as for navigation.

Construction began in June 1827, and by October, there were 400 workers under the direction of Canvass White, who had overseen the building of the Erie Canal, at work on the canal. It was finished two years later, and on November 10, 1829, the opening of the Enfield Falls Canal was marked with a celebration, which included a demonstration by the first steamboats built for regular service on the river above Hartford.

After the canal's completion, daily trips by steamboats were made between Hartford and Springfield. Charles Dickens made the trip from Springfield to Hartford on a small steamer on

February 7, 1842. In the record of his 1842 visit to America, *American Notes*, Dickens writes that the steamboat stopped at a small town, believed to be Windsor Locks, where the vessel and passengers were saluted by a gun considerably bigger than the boat's chimney.

At the time of Dickens's visit, the village that had grown up along the canal was known as the Locks. In 1854, at the suggestion of the canal officials, who desired some recognition for the credit due the canal in the growth of the town, the name Windsor Locks became the accepted name of the community.

In 1844, the Hartford and Springfield Rail Road Company began operating in the valley. Because of the speed and convenience afforded by rail transit, water transportation for both freight and passengers on the Connecticut River above Hartford decreased substantially, and the receipts of the Connecticut River Company obtained from tolls rapidly dwindled. The company realized that in the future income from the canal must come from its capacity to furnish power. Mills were built on the canal banks, and for over 100 years, textiles, cutlery, wire, paper, and other products were manufactured along the canal.

The canal's use as an industrial setting has declined in recent years. One by one the mills on the canal moved to other locations or went out of business, today leaving only the specialty paper manufacturer Ahlstrom on the canal bank. The Connecticut River has slowly been reclaiming its rightful progeny, the canal, and it has once again become a fit home for wildlife and native plants. Visitors come to this special place to bird-watch, fish, hike, and bicycle.

The story of the canal has not ended. There are important chapters to be written in the coming decades. Development pressures, recreational uses, preservation of open space, and the protection of wildlife and native plant species will play important roles in any future narrative of the canal.

One

THE RIVER NEXT DOOR

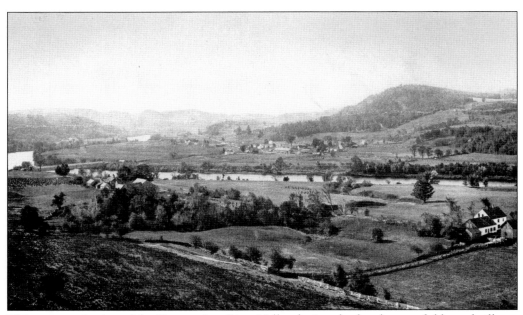

This panoramic view of the Connecticut River Valley depicts the farmhouses, fields, and villages that occupied large stretches of the valley in the 1890s. (LAWP.)

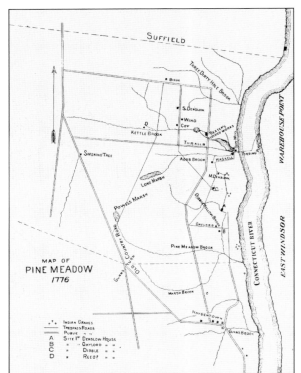

The little settlement at Pine Meadow was not named Windsor Locks until after the canal was built in 1829. This 1776 map of Pine Meadow shows the houses of residents, Dexter's Clothier Works, a sawmill next to the Connecticut River, and the graves of Native Americans.

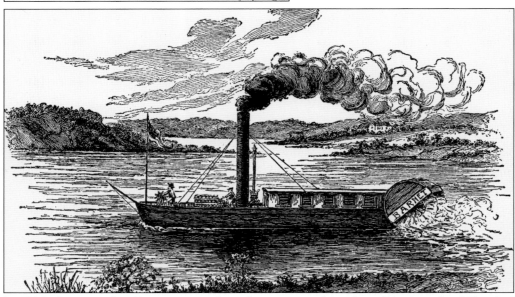

In 1826, the steamship *Barnet* attracted much attention along the villages north of Hartford during its maiden trip from Hartford to Bellow's Falls, Vermont. The first steamboat to come above Hartford, it was greeted by wild cheering and gunfire from both sides of the river. The trip had been sponsored by the Connecticut River Company, which wanted to show the superiority of steamboats over flatboats in navigating the river. The success of the *Barnet*'s first trip spurred activity on the canal.

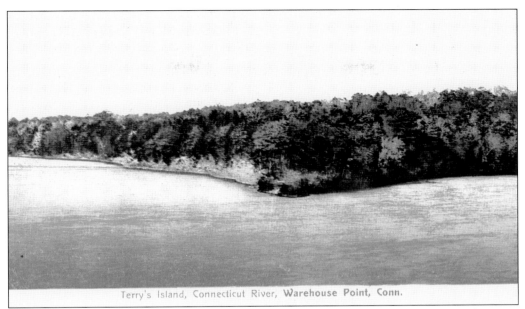

Terry's Island, Connecticut River, Warehouse Point, Conn.

Pictured here is the southern end of King's Island. Situated in the Connecticut River between the towns of Suffield and Enfield, the island is a natural landmark, rising at its highest point 73 feet above the normal river level. King's Island was better known as Terry's Island during the last quarter of the 19th century and much of the 20th century, as the caption of this c. 1900 postcard shows. (EPL.)

Tarry Island, Windsor Locks, Conn.

The southern tip of the island is shown in this c. 1907 image. The railroad bridge, built in 1903, is just visible in the background of this image. In 1864, the southern part of the island was purchased by DeWitt Clinton Terry, who cleared and cultivated the land and built a clapboard house on a high knoll. He and his family lived there until 1889. (LAWP.)

In this 1909 photograph of the island, the canal and towpath can be clearly seen. Densely wooded, the island has been cut over twice, the last time during the 1930s, for its timber, including hemlock, white pine, poplar, and oak. Today the island is home to wintering bald eagles.

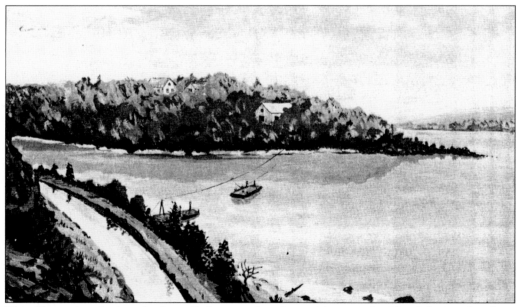

This illustration depicts the large flatboat used to ferry visitors to the island during the three decades it was occupied by the Terry family. The flatboat, which was operated by DeWitt Clinton Terry, ran back and forth along a wire cable. After crossing the canal to the towpath, either by boat or one of the bridges at Windsor Locks, visitors walked to the landing place where they would board the ferry. (LAWP.)

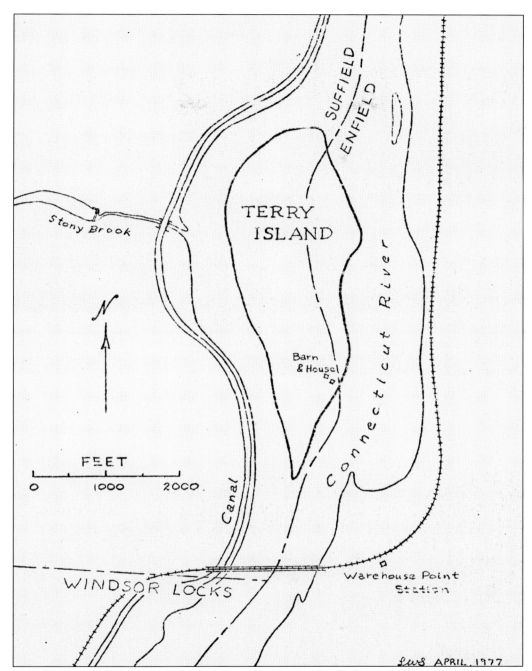

This 1977 map of Terry's Island (also known as King's Island) shows the locations of the stone foundations of the Terry house and barn. The map was drawn by Lester Smith of Suffield after a visit to the island in 1975. Several Native American burial grounds are also said to be on the island. (KML/SHS.)

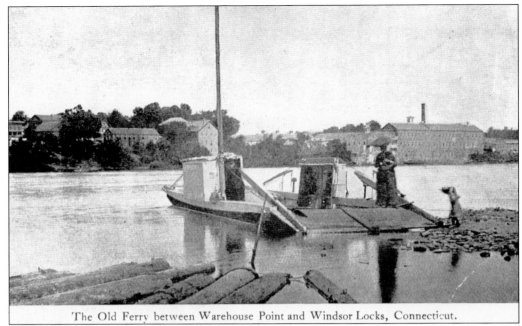

The Old Ferry between Warehouse Point and Windsor Locks, Connecticut.

This image shows the old ferry between Windsor Locks and Warehouse Point around 1885. The ferry is moored on the Warehouse Point side of the river, and the mills in Windsor Locks can be seen across the river. The ferry, which had been in operation since 1783, was discontinued when the two villages were connected by a suspension bridge in 1886. (LAWP.)

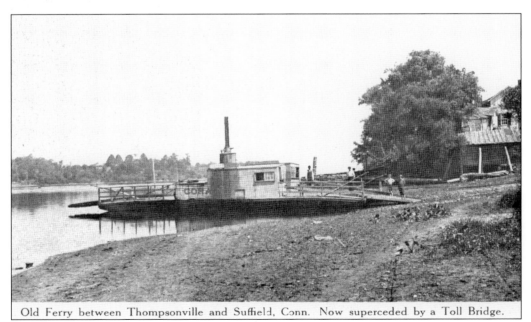

Old Ferry between Thompsonville and Suffield, Conn. Now superceded by a Toll Bridge.

The *Cora*, the ferry between Thompsonville (a section of Enfield) and Suffield, is depicted in this *c.* 1890 postcard. The owner of the *Cora* was Servillios Griswold. The ferry was discontinued in 1892 upon completion of the toll bridge. (KML/SHS.)

14

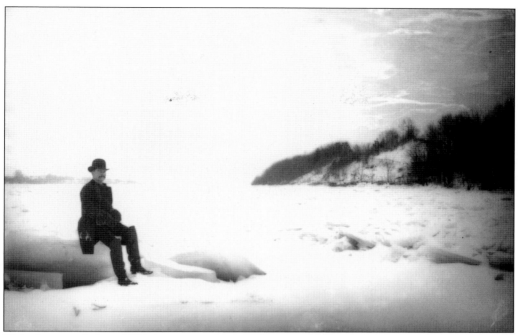

This photograph from 1909 shows a gentleman fishing on the frozen Connecticut River. (LAWP.)

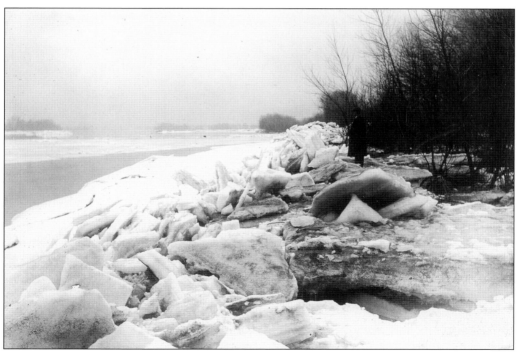

In this *c.* 1909 image, slabs of ice are piled up along the banks of the Connecticut River. As winter changed to spring, ice on the Connecticut River would break up and be forced onto the shores by the irresistible power of the river as it flowed downstream. (LAWP.)

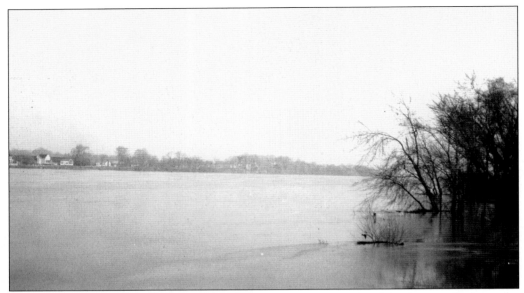

The river's banks are underwater from melting ice upstream in this photograph from the 1930s. (EPL.)

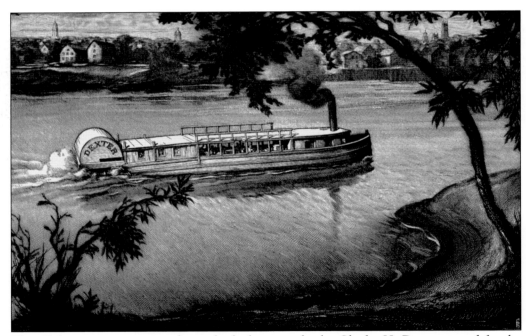

This 19th-century engraving shows the little stern-wheeler *Charles H. Dexter*, named for the owner of the Dexter mills in Windsor Locks. The 82-foot-long *Dexter* was built at a small yard on the riverbank at Suffield in 1866. It was the last steamboat to run on the river above Hartford. (DRC, C. H. Dexter Company Records.)

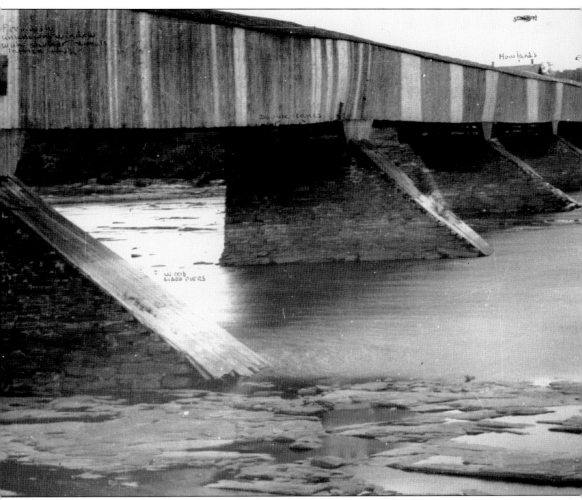

Enfield's first bridge was a covered wooden toll bridge built in 1808 and was, according to most sources, the first bridge across the Connecticut River in the state. In this *c.* 1890 photograph, notice that the sloped icebreaker piers on the upstream side are wood-sided. According to the photograph, on the far upper left corner of the photograph, an open window with shutter reveals a lattice truss. (EPL.)

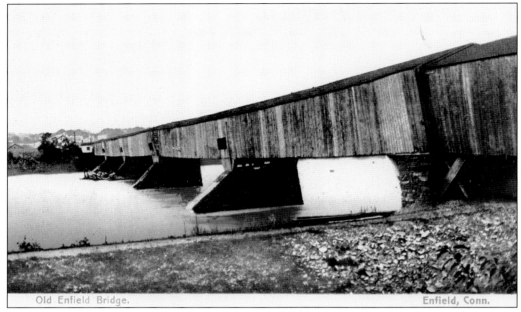

Old Enfield Bridge. Enfield, Conn.

In this upstream view from the late 1880s, the Enfield bridge's icebreaker piers can be seen as well as the toll collector's building at the far end on the Enfield side. A well-worn path is also visible on the riverbank on the Suffield side of the bridge. (EPL.)

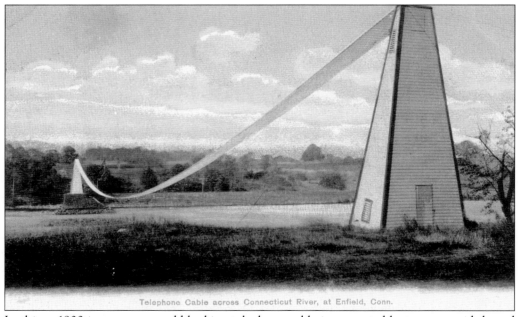

Telephone Cable across Connecticut River, at Enfield, Conn.

In this c. 1900 image, a very odd-looking telephone cable is supported by two pyramid-shaped structures on the east and west banks of the Connecticut River between Suffield and Enfield. Note what appears to be a door and window in the support structure in the foreground. (DRC, Leroy Roberts Connecticut Railroad Station Photographs Collection.)

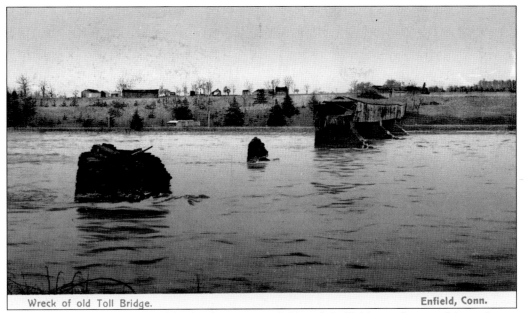

Wreck of old Toll Bridge. Enfield, Conn.

The old wooden covered toll bridge between Enfield and Suffield was destroyed by a fire in the early 1890s. The aftermath is documented in this 1906 postcard. (DRC, Leroy Roberts Connecticut Railroad Station Photographs Collection.)

These piles of stones are believed to be the remains of the piers from the wrecked Enfield toll bridge. (EPL.)

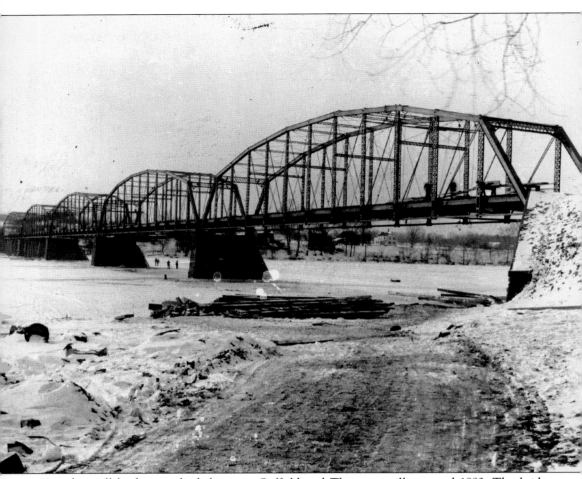

Another toll bridge was built between Suffield and Thompsonville around 1893. The bridge was located at the west end of Main Street in the Thompsonville section of Enfield beyond the railroad arch. Notice that workers are cutting and installing planking for the bridge's roadway in this *c.* 1893 photograph. Other individuals are standing under the bridge in the middle of the frozen river. The bridge was demolished by dynamite in 1971. The narrow two-lane structure was replaced by the present-day modern span located about one mile south of the old bridge in 1967. (EPL.)

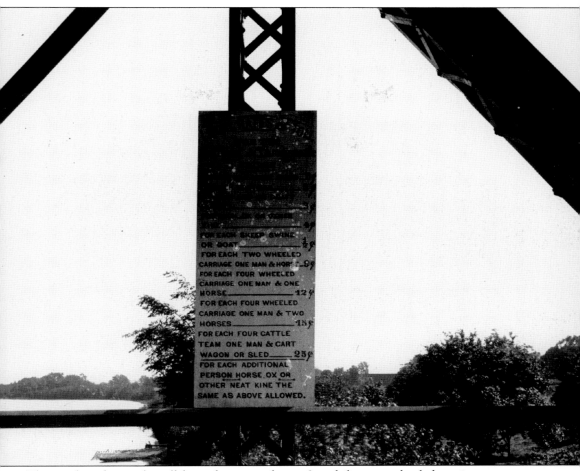

FOR EACH SHEEP SWINE
OR GOAT_____ ½¢
FOR EACH TWO WHEELED
CARRIAGE ONE MAN & HORSE__9¢
FOR EACH FOUR WHEELED
CARRIAGE ONE MAN & ONE
HORSE_____ 12¢
FOR EACH FOUR WHEELED
CARRIAGE ONE MAN & TWO
HORSES_____ 15¢
FOR EACH FOUR CATTLE
TEAM ONE MAN & CART
WAGON OR SLED_____ 25¢
FOR EACH ADDITIONAL
PERSON HORSE OX OR
OTHER NEAT KINE THE
SAME AS ABOVE ALLOWED.

This signboard gives the toll for each man on foot as 3¢, while a two-wheeled carriage, one man, and horse is 9¢. Note that there are no charges listed for motor vehicles, dating this image to most likely before 1900. (EPL.)

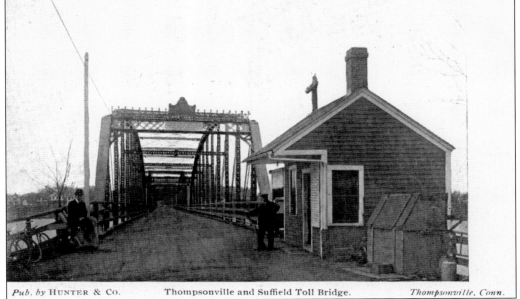

Pub. by HUNTER & CO. Thompsonville and Suffield Toll Bridge. *Thompsonville, Conn.*

This *c.* 1900 image of the bridge on the Enfield side shows a stylishly dressed gentleman sitting on a bench, bicycles, and another gentleman, who is most likely the toll collector, standing next to the toll collector's building. (DRC, Leroy Roberts Connecticut Railroad Station Photographs Collection.)

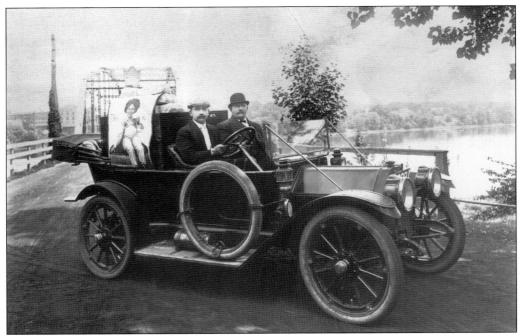

This *c.* 1910 photograph of George Lehman (left), owner of Lehman's Bakery, and his father, Gottlieb, shows them driving along a delivery route with a bread advertisement positioned in back. Baked goods are piled in the back of the automobile. (EPL.)

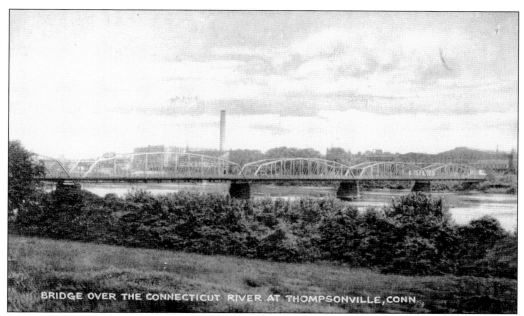

The Suffield and Thompsonville Bridge is seen from the west bank of the Connecticut River. The Bigelow-Sanford Rug Company and a smokestack are visible in the distance in this *c.* 1906 image. (EPL.)

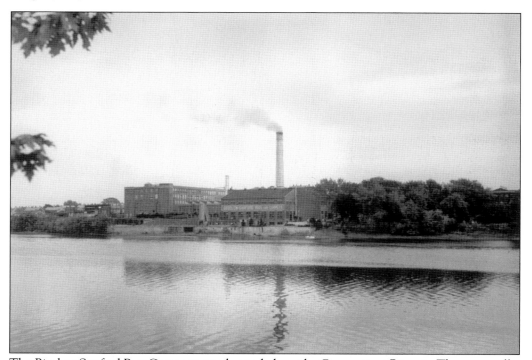

The Bigelow-Sanford Rug Company was located along the Connecticut River in Thompsonville. This photograph, taken in the early 1950s, gives a more detailed picture of the company. (DRC, Southern New England Telephone Company Records.)

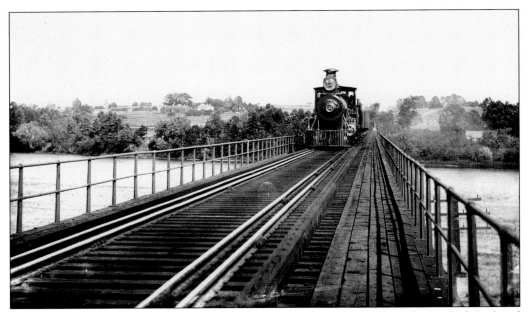

Shown here, in a photograph dated 1891, a New York, New Haven and Hartford Railroad locomotive is crossing the Connecticut River on the white iron single-track bridge that was in operation from 1865 until 1903. (LAWP.)

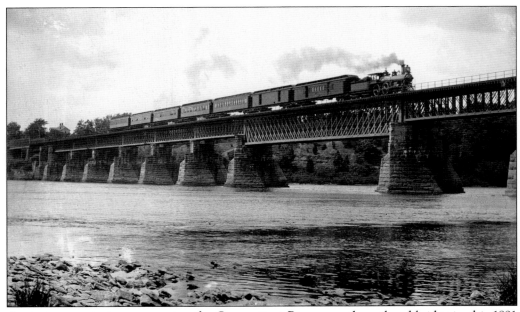

A passenger train is seen crossing the Connecticut River over the railroad bridge in this 1891 photograph. (LAWP.)

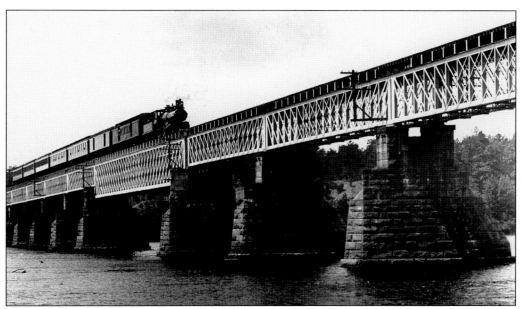

Here is a much closer view of the passenger train as it crosses the river and then heads north. Notice the electric poles attached to the side of the bridge. (LAWP.)

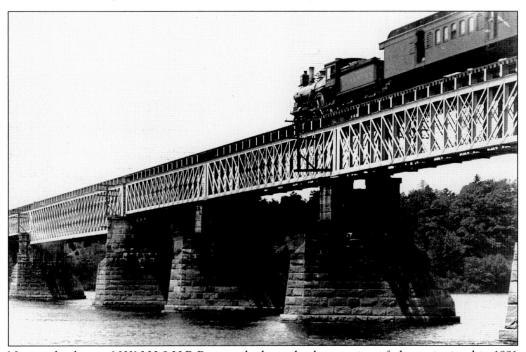

Notice the letters N.Y.N.H.&H.R.R. inscribed on the locomotive of the train in this 1891 photograph. In 1847, the Hartford and Springfield Rail Road Company became part of the Hartford and New Haven line. The latter company consolidated with the New York and New Haven Railroad Company in 1871 to become the New York, New Haven and Hartford Railroad Company. (LAWP.)

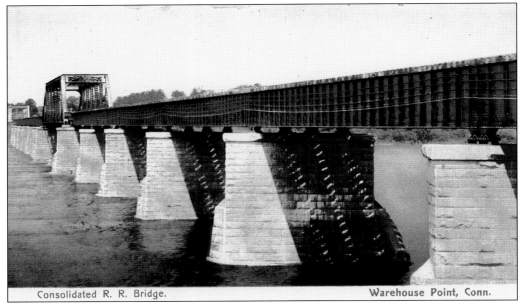

Consolidated R. R. Bridge. Warehouse Point, Conn.

A new railroad bridge across the river was built in 1903. This *c.* 1908 image shows the bridge's piers, with sloped masonry icebreakers on the upstream side. (DRC, Leroy Roberts Connecticut Railroad Station Photographs Collection.)

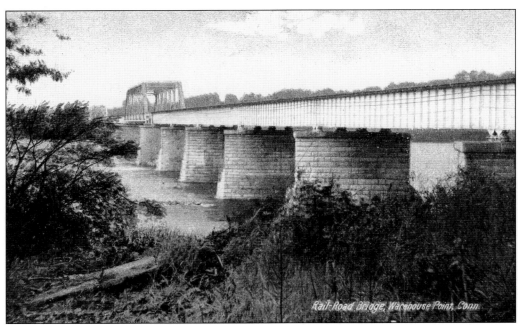

Rail-Road Bridge, Warehouse Point, Conn.

Another view of the railroad bridge, seen from the east bank of the river, is presented in this *c.* 1908 postcard. (DRC, Leroy Roberts Connecticut Railroad Station Photographs Collection.)

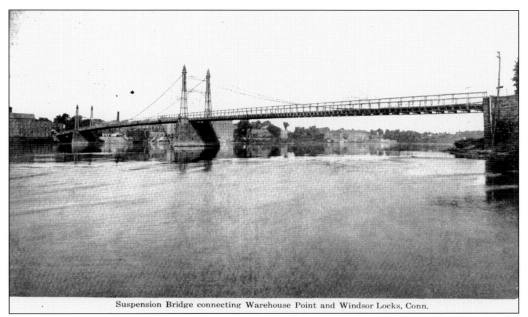

Suspension Bridge connecting Warehouse Point and Windsor Locks, Conn.

In 1885–1886, a three-span suspension bridge was built over the Connecticut River by the Windsor Locks and Warehouse Point Bridge and Ferry Company, replacing the ferry. Dedicated in 1886, the one-lane toll bridge carried State Aid Road No. 20, now Route 140, over the Connecticut River between Windsor Locks and Warehouse Point (a section of the town of East Windsor). This c. 1900 photograph of the bridge was taken from the east bank of the river. Notice the mills located on the Windsor Locks side of the bridge. (LAWP.)

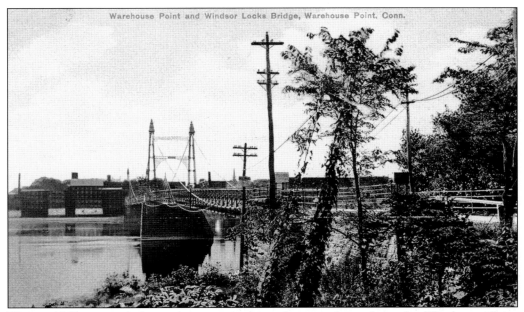

This c. 1905 postcard shows the massive stone abutment located on the Warehouse Point side of the suspension bridge. The back of the Medlicott textile mill can be seen across the river. (LAWP.)

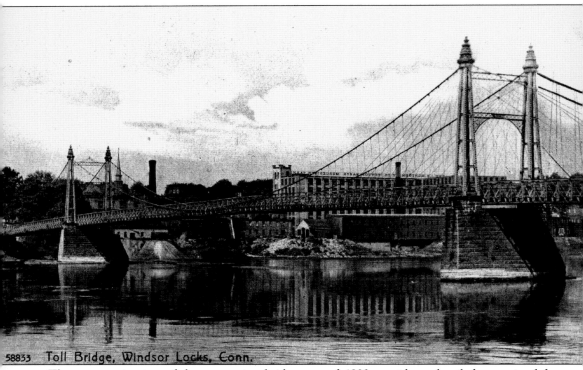

58833 Toll Bridge, Windsor Locks, Conn.

The panoramic view of the suspension bridge around 1892 provides a detailed portrait of the structure. The bridge from one abutment to the other measured about 122 feet. There were abutments on each riverbank and two piers in the river, with sloped masonry icebreakers on the upstream side. The main suspension cables were anchored below ground at each end, then draped over a cast-iron saddle to change direction, and then placed over the two towers on the river piers. Each main suspension cable was comprised of bundles of twisted wire rope. The

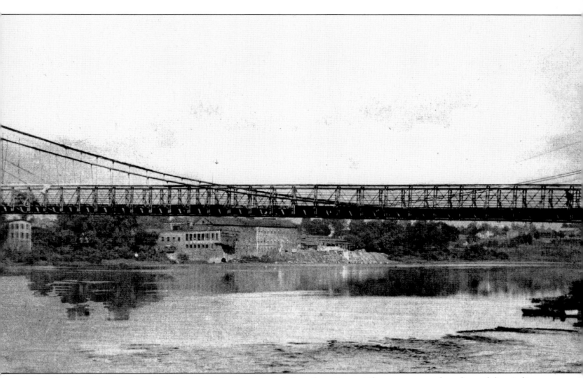

use of twisted wire rope was somewhat unusual for the time. The process, developed by John Roebling in the 1840s and used on the Brooklyn Bridge and most big suspension bridges since then, involves a large number of wires laid parallel, then compressed into cylindrical form and wrapped with a layer of wire to maintain the shape and protect the cable. There is no twist at all in any of the wires making up the suspension cables on the Brooklyn Bridge or most big suspension bridges. (LAWP.)

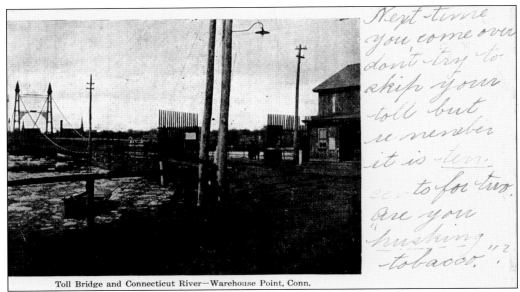

Toll Bridge and Connecticut River—Warehouse Point, Conn.

In this image dated 1906, the Warehouse Point side of the bridge is pictured. There appears to be a small boat anchored near the east bank of an ice-filled Connecticut River. On the postcard, the correspondent admonishes the person receiving the card, "Next-time you come over don't try to skip your toll but remember it is ten cents for two." (DRC, Leroy Roberts Connecticut Railroad Station Photographs Collection.)

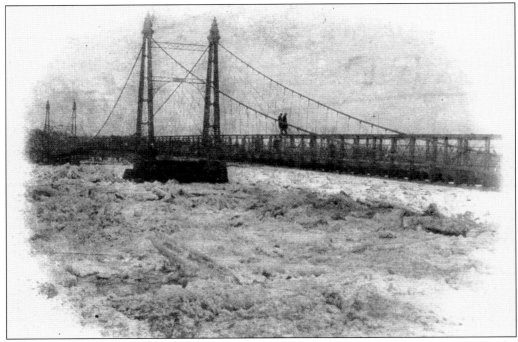

Another image dated the following year shows the suspension bridge above a frozen river. In the waning light, two individuals are walking on top of the bridge's railing while holding on to the cable. (LAWP.)

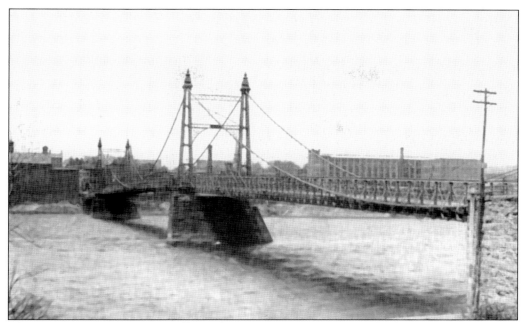

The Montgomery Company mill can be seen to the right in the background of this image of the toll bridge. In 1907, it cost an individual driving a touring car 25¢ to cross the bridge; a horse, wagon, and driver cost 12.5¢; and a person on foot cost 3¢. The heavy toll charged automobile owners every time the bridge was crossed discouraged residents in the area from buying automobiles.

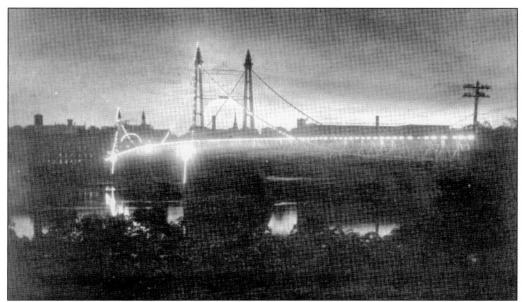

The Windsor Locks and Warehouse Point suspension bridge was the first of four toll bridges in Connecticut to be made free when it was purchased by the state in 1909. This photograph, in which the bridge is outlined by more than 1,000 electric lights, was taken in 1909 during the celebration held on July 18, 1909, to mark the freeing of the bridge as a toll bridge.

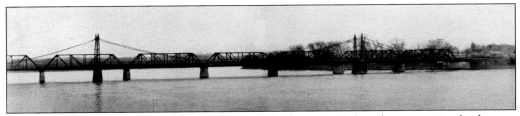

The suspension bridge was replaced with a truss bridge in 1921, but the suspension bridge was not removed until several years after the new bridge was completed. This photograph taken from the north window of a Dexter company building clearly shows both the truss and suspension bridges still standing in 1924, when the new Dexter building was constructed. (DRC, C. H. Dexter Company Records.)

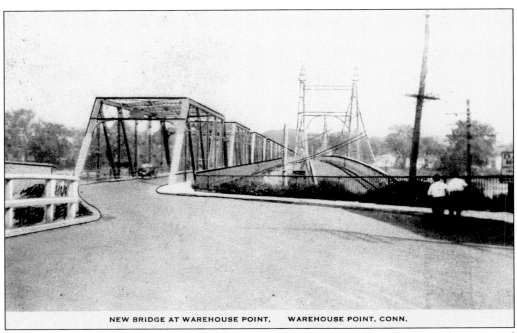

NEW BRIDGE AT WAREHOUSE POINT. WAREHOUSE POINT, CONN.

Both the truss and suspension bridges are pictured existing simultaneously in this postcard dated 1927. The S run necessitated to align the roadway can be clearly seen. The misalignment of the bridge with the roadway on both ends resulted from the 1921 truss bridge being constructed immediately adjacent to the older structure, necessitating two S runs for roadway alignment. (LAWP.)

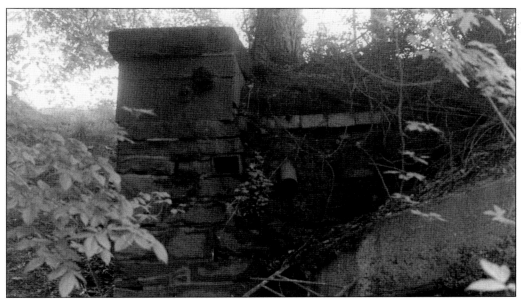

In this photograph, the remains of the west abutment of the suspension bridge are documented by a 1988 archaeological survey conducted by the state. The survey found that the suspension bridge abutments were still either largely intact or at least partially visible. The entire East Windsor abutment was still intact, and half of the Windsor Locks abutment was visible, the other half having been removed or covered by approaches built for the 1921 seven-span Pratt through truss bridge situated immediately north of the former suspension bridge. (DRC, Connecticut Historic Preservation Collection.)

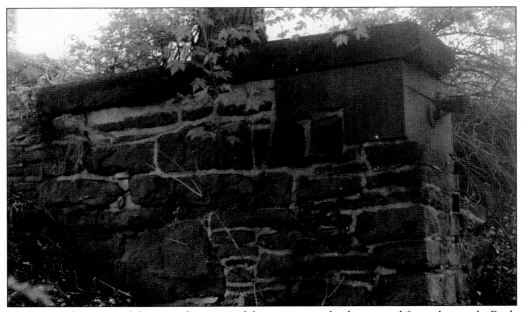

Here is another view of the west abutment of the suspension bridge viewed from the south. Both abutments were removed when the truss bridge was replaced by the present concrete Dexter Coffin bridge. (DRC, Connecticut Historic Preservation Collection.)

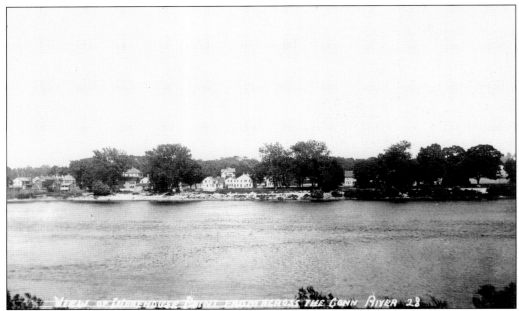

This *c.* 1928 view is of Warehouse Point from across the Connecticut River. (LAWP.)

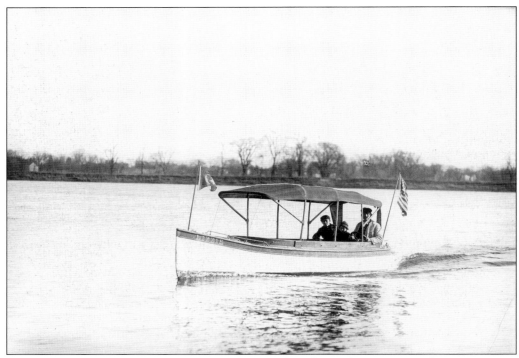

Pictured here are a father and sons traveling in their boat, the *Lizzie*, on the Connecticut River. (LAWP.)

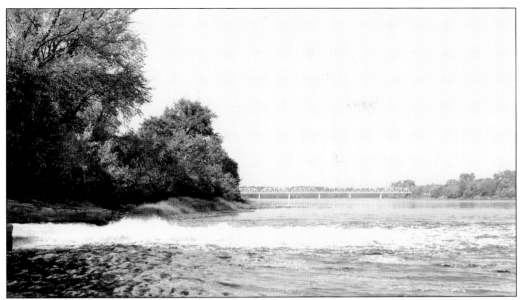

This 1948 photograph was taken from the west bank of the Connecticut River downstream from the truss bridge (which was also known as the Bridge Street Bridge). In 1921, the State of Connecticut erected this structure immediately north of the suspension bridge. The bridge was built by the Berlin Construction Company. (DRC, Southern New England Telephone Company Records.)

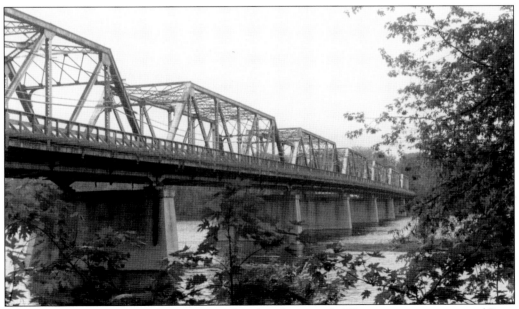

A closer view of the truss bridge is presented in this photograph. The structure was a riveted Pratt through truss design consisting of seven spans of approximately 152 feet each. The misalignment of the bridge with the roadway on both ends resulted from the truss bridge being constructed immediately adjacent to the older structure, necessitating two S runs for roadway alignment. (DRC, Connecticut Historic Preservation Collection.)

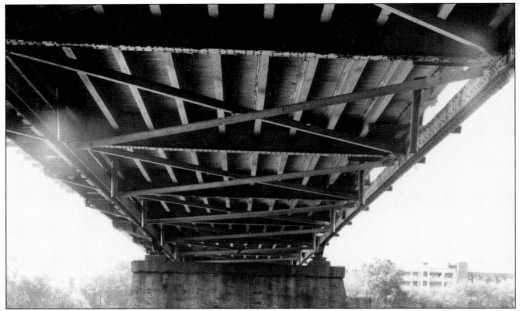

This view is of the underside of the truss bridge at the east end, looking west. The total length of the bridge was 1,604 feet. The abutments, wing walls, and piers were reinforced concrete, supported on bedrock in the case of the western three piers and abutment, and on timber pilings carried to bedrock for the eastern three piers and abutment. (DRC, Connecticut Historic Preservation Collection.)

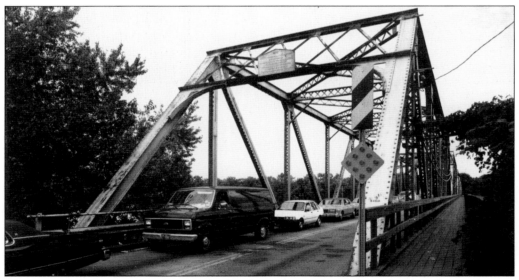

This view of the west end of the truss bridge shows the six-foot-eight-inch sidewalk cantilevered off the south truss. The original two-inch wooden planking of the sidewalk was replaced by a concrete-filled steel grid in 1938. In 1984, serious buckling of the sidewalk slabs necessitated construction of a temporary wooden sidewalk the full length of the bridge. The sidewalk was used by hundreds of fishermen during the spring shad season. (DRC, Connecticut Historic Preservation Collection.)

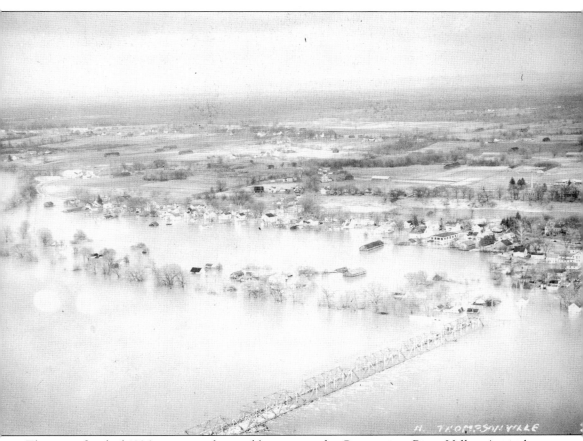

The great flood of 1936 was an unforgettable event in the Connecticut River Valley. An early, warm spring caused the frozen Connecticut River to break up into huge ice floes, creating an ice jam that dammed the river. When the dam finally burst, the river overflowed its banks, flooding towns and farms, destroying homes and bridges, and leaving thousands of people homeless. This panoramic view shows floodwaters inundating the bridge and much of Warehouse Point in March 1936. (LAWP.)

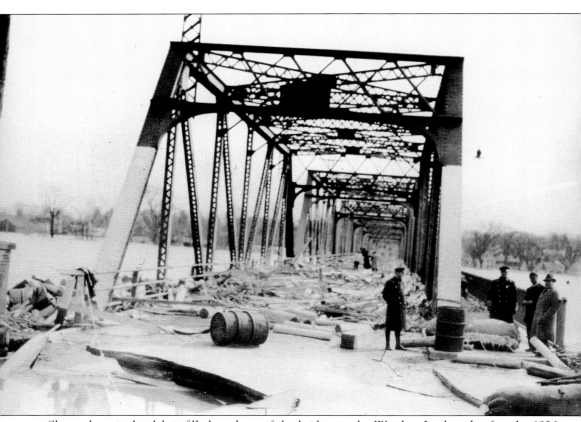

Shown here is the debris-filled roadway of the bridge on the Windsor Locks side after the 1936 floodwaters had subsided. (LAWP.)

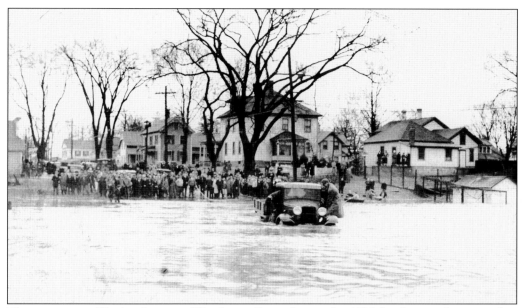

This is a view of Bridge Street in Warehouse Point during the 1936 flood as residents watch a truck attempt to make its way through the floodwaters. (LAWP.)

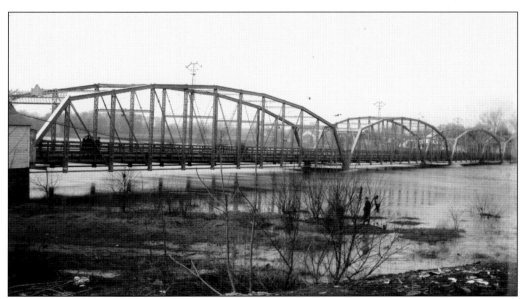

The 1936 floodwaters have almost reached the roadway of the Suffield and Thompsonville Bridge in this photograph. Notice the individuals standing at the edge of the floodwaters. (EPL.)

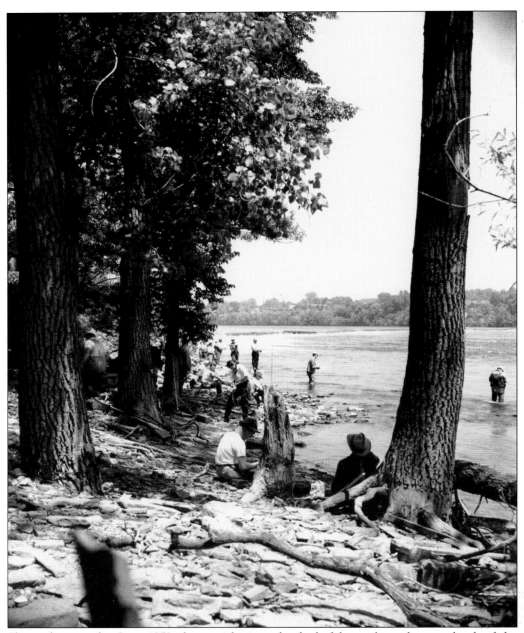

Shown here in this June 1952 photograph are individuals fishing along the west bank of the Connecticut River near the Enfield Dam. Although these anglers were probably fishing for shad, smallmouth bass, striped bass, herring (alewives and bluebacks), and the rare Atlantic salmon, shortnose sturgeon and sea-run brown trout can also be caught in the river. (DRC, Southern New England Telephone Company Records.)

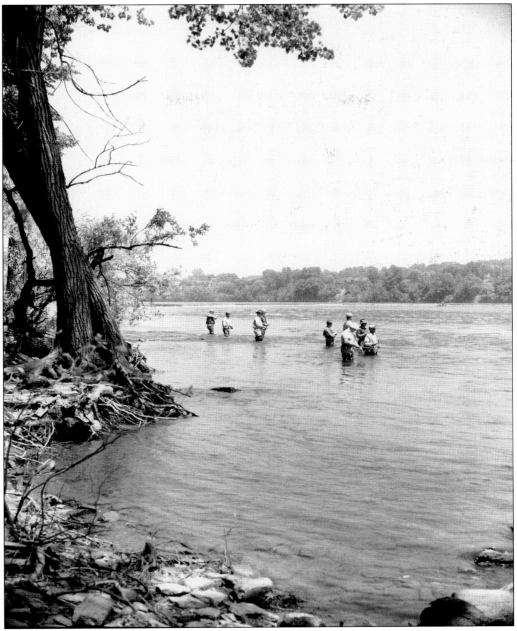

Anglers wade into the Connecticut River near the Enfield Dam in this June 1952 image. (DRC, Southern New England Telephone Company Records.)

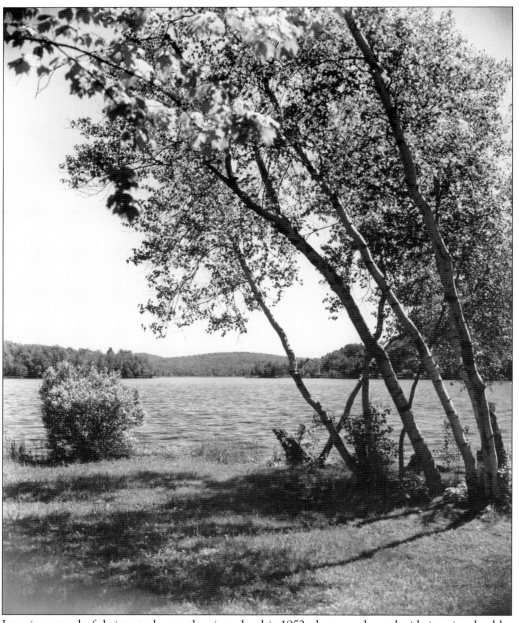

June is a wonderful time to be on the river. In this 1952 photograph, a placid river is edged by distant hills. (DRC, Southern New England Telephone Company Records.)

Two

FEATURES AND STRUCTURES

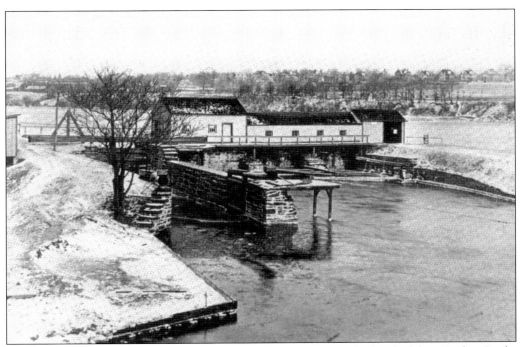

This *c.* 1909 photograph shows the gatehouse and guard lock at the head of the Windsor Locks Canal. A steel drawbridge spans the lock entrance just above the upper gates. Two lockkeepers were stationed at each lock. In addition to their job of opening and closing the lock gates and letting the water in and out, the men also collected tolls, passed upon the type of boat that could use the canal, and patrolled the waterway on the lookout for leaks or damage of any kind. (KML.)

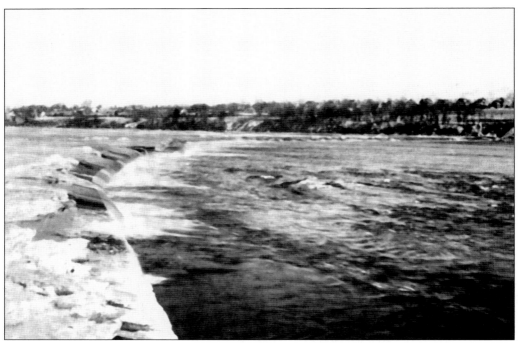

The Enfield Dam was photographed in 1909 from the gatehouse, looking east. The canal joins the river at the dam. (KML.)

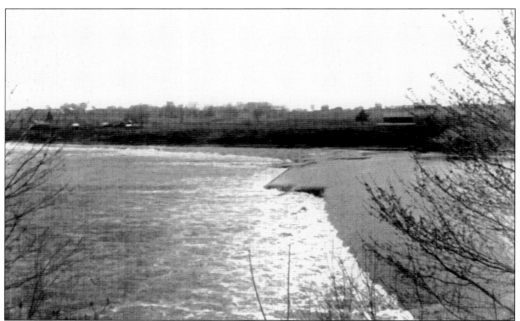

Here the Enfield Dam is viewed from the east bank of the river, looking west, in this early-20th-century photograph. The dam was a wooden crib (box) structure (crisscrossed logs or squared-off timber) filled with stone. It was utilized to create a pool of water in the river above the rapids to supply the canal with water for the functioning of the canal locks. (KML.)

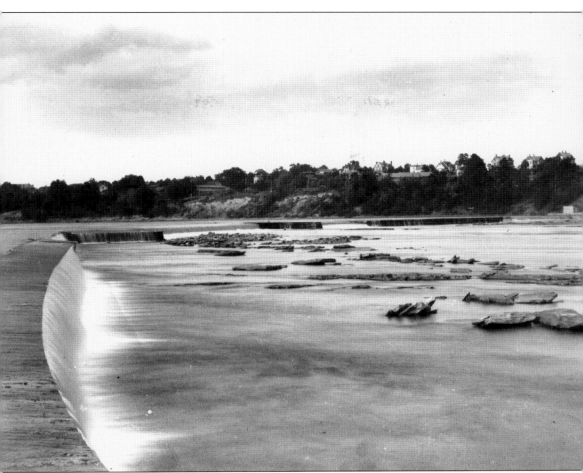

The Enfield Dam is shown in this *c.* 1900 image. At the completion of the canal, no dam had been built across the river at its head. A wing, which served to divert a portion of the river's water into the canal, had been thrown out from the western bank at the head of the falls reaching to the middle of the river. The wing was high enough above the river to form a basin and safe entrance to the guard lock. In 1849, the Connecticut River Company was allowed to run another wing from the eastern side, leaving a clear space of 70 feet in the center for the passage of boats and rafts. In 1881, the two wings were united and the general level of the whole length of the dam was slightly raised. (EPL.)

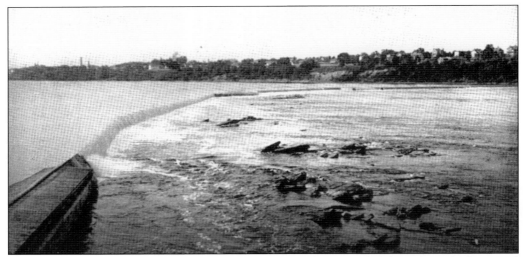

Shown in this c. 1908 image is a portion of the long pier that extended down from the lower end of the dam parallel to the west bank. (KML.)

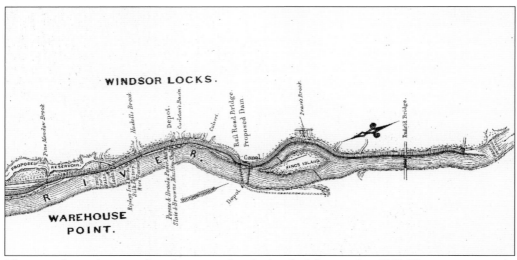

This map shows the wing dam that existed at the head of the canal in 1829. The map is part of a larger map of an 1847 survey for a proposed canal route from Enfield Falls to Hartford. (KML.)

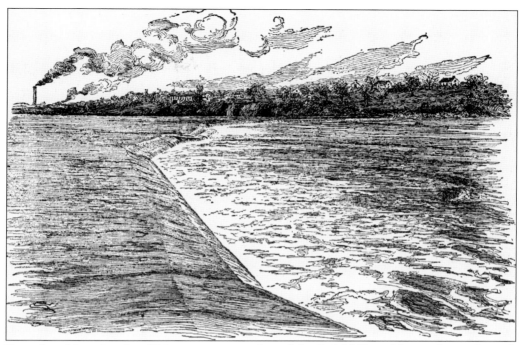

Reproduced here is a late-19th-century engraving of the Enfield Dam. Notice the smokestack and homes on the Enfield (eastern) side of the Connecticut River.

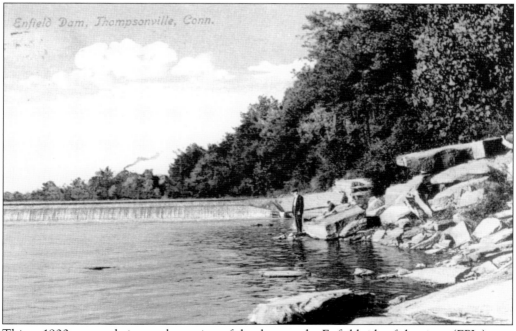

Enfield Dam, Thompsonville, Conn.

This *c.* 1900 postcard gives a closer view of the dam on the Enfield side of the river. (EPL.)

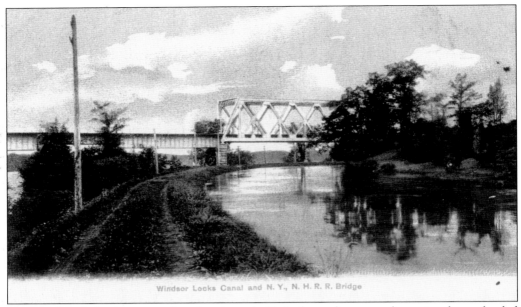

The tracks of the horses and mules that plodded along the towpath towing boats loaded with freight are clearly visible in this *c.* 1905 view of the canal just north of the railroad bridge. (LAWP.)

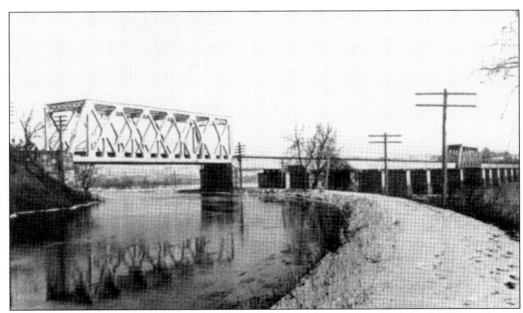

This *c.* 1908 photograph of the canal and towpath was taken just south of the double-track steel railroad bridge. (KML.)

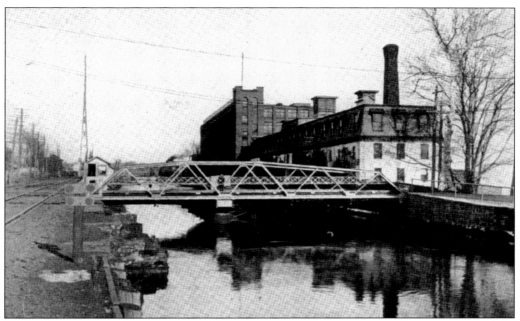

The bridge photographed here in 1909 was known as the Highway Bridge because it carried the state highway (now Route 140) over the canal, connecting it with the suspension bridge that crossed the river. The Montgomery Company building can be seen behind the Anchor mill. The Medlicott textile mill is out of view on the other side of the Highway Bridge. (KML.)

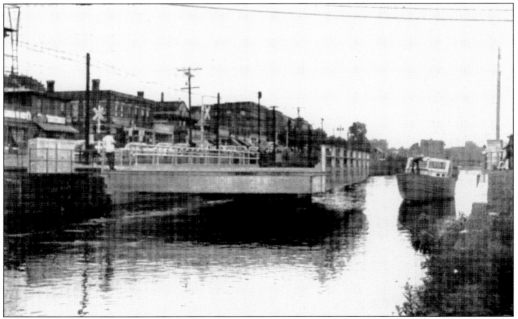

The old Highway Bridge was replaced by a steel swing bridge, which allowed boats to pass through the canal. The swing bridge was probably constructed in 1921 when the truss bridge over the Connecticut River was built.

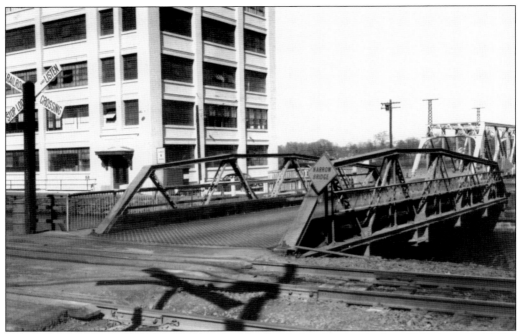

Notice the Narrow Bridge sign in this photograph, likely taken in the late 1940s or early 1950s. This bridge, which replaced the earlier swing bridge, was a one-way bridge and caused frequent traffic backups on Main Street in Windsor Locks. (DRC, Leroy Roberts Connecticut Railroad Station Photographs Collection.)

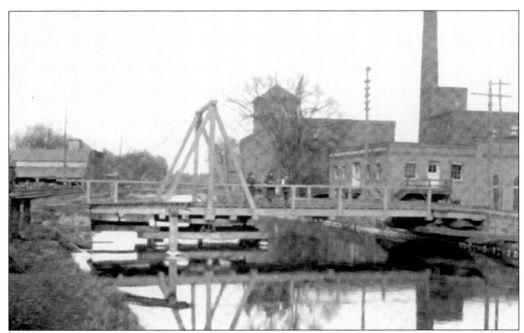

The Memorial Hall Bridge pictured in this *c.* 1900 image crossed the canal about a quarter of a mile south of the Highway Bridge. (KML.)

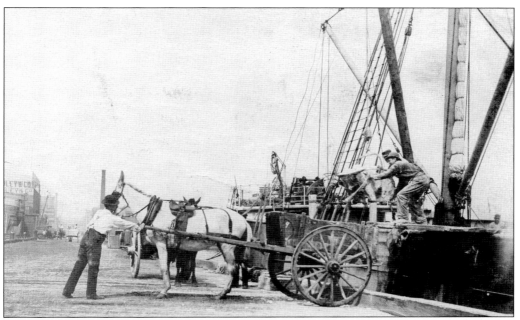

This *c.* 1890 photograph shows workers on a dock loading freight from a boat onto a horse-drawn wagon. The docks along canals were built to allow boats to come close to the edge for loading and unloading. On towpath canals, docks are usually on the berm side (opposite to the towpath), keeping the towpath clear for towing. (DRC, C. H. Dexter Company Records.)

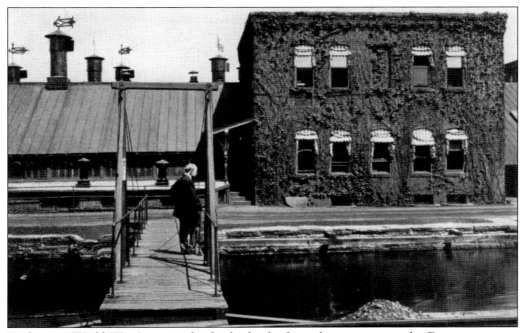

In this pre–World War I image, the footbridge leads to the entrance to the Dexter company offices, which are located in the vine-covered older sections of the mill. (DRC, C. H. Dexter Company Records.)

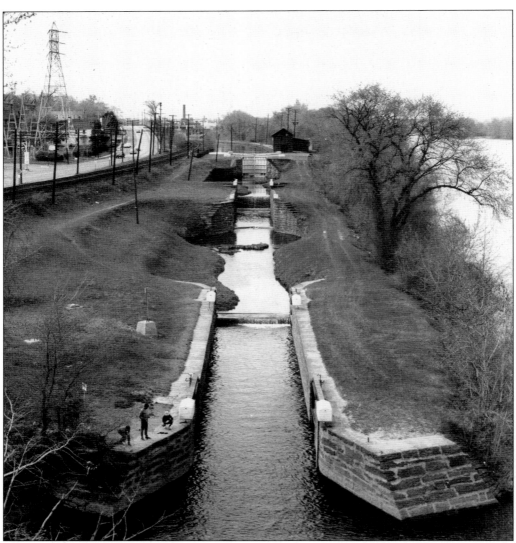

This overhead view from the 1960s shows the flight of locks at the lower (southern) end of the Windsor Locks Canal. The three masonry locks, each of 10 feet lift, were separated by wide pools in which ascending and descending boats could pass each other. The locks allowed boats to move from one level of the canal to another. At either end of the lock were the gates. Butterfly valves in the gates allowed water into the lock from above and let it out to the level below. Notice the gentleman in the striped shirt climbing the wall of the lock in the lower left corner of the picture. (DRC, C. H. Dexter Company Records.)

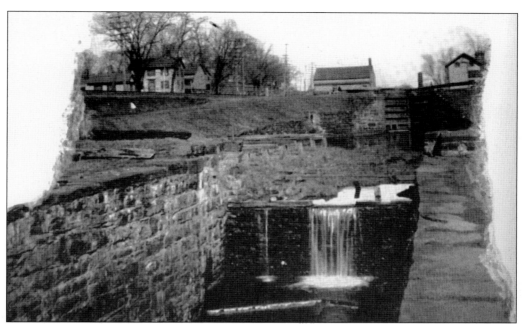

This 1897 photograph shows the locks at the southern end of the canal. Note the stone masonry walls of the locks shown in the lower portion of the picture. Two gates at the end of each lock were hinged into the masonry walls, which proved to be very durable. (EPL.)

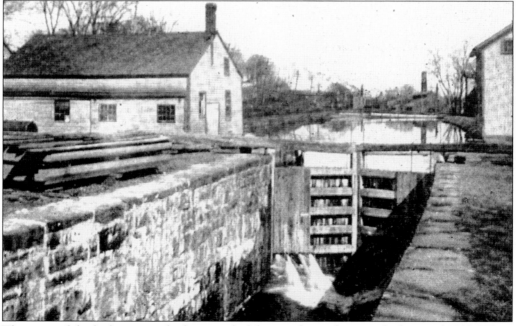

This view of the lock gates at the lower end of the canal was photographed around 1897. When boats were to pass through the canal, musical whistles from the steamer or other vessel would notify the lockkeeper (also called a lock tender) to close the gates and gauge the water level before locking the boats through. (EPL.)

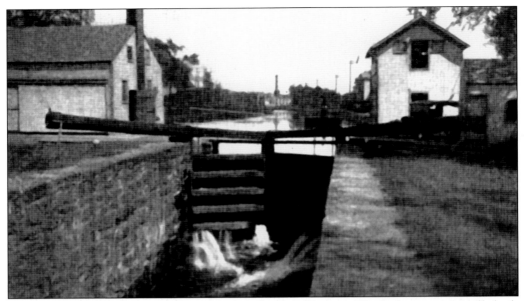

Another view of the lock gates is presented in this c. 1897 image. The locks were originally built of stone, without mortar, and lined with wood to save expense. When the wood rotted away, costly repairs were necessary. Notice the nearby buildings. One was probably a lockhouse, where the lockkeeper lived. (EPL.)

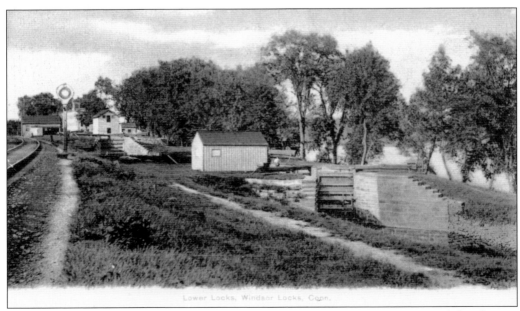

The locks and buildings at the lower end of the canal are shown in this postcard dated 1908. The small building above the lowest lock may be a valve house. A figure can be seen standing next to the building—perhaps the lockkeeper. (CP.)

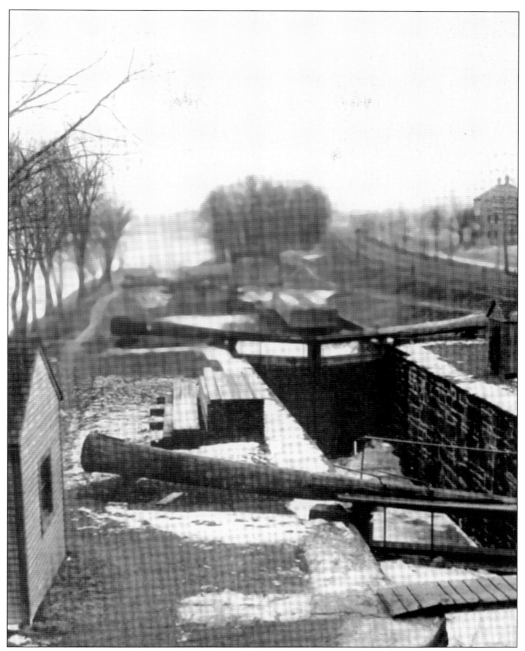

The lock is a long box with a floor, two parallel walls, and gates at each end. These features can be clearly seen in this c. 1900 photograph. Also shown are the long wooden sweeps, or levers, that were bolted across the tops of the gates and extended out over the embankment. Men pushed the sweeps to open the lock gates. (KML.)

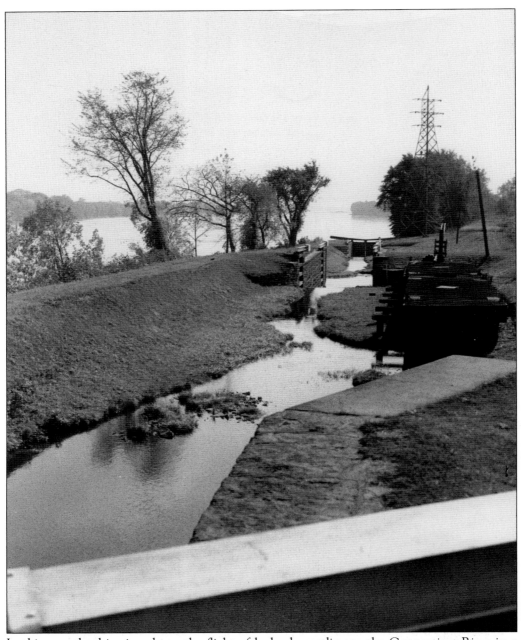

Looking south, this view shows the flight of locks descending to the Connecticut River in a photograph dated 1948. (DRC, Southern New England Telephone Company Records.)

Three

INDUSTRY ALONG THE CANAL

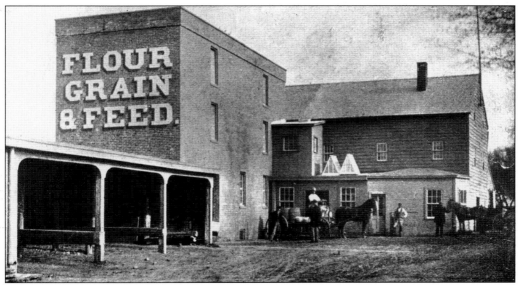

This *c.* 1900 photograph shows the saw- and gristmill built by Seth Dexter and Jabez Haskell in 1819 near the dam at Kettle Brook in the Pine Meadow section of Windsor. It was here in the basement that Seth Dexter's son Charles Haskell Dexter first began manufacturing paper in 1835. (DRC, C. H. Dexter Company Records.)

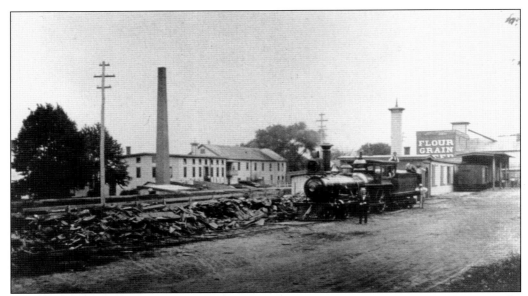

The saw- and gristmill pictured here, built in 1819, was referred to as "the old grist mill." However, an even older gristmill had been built by Seth Dexter and Jabez Haskell in 1784. It was located near the mouth of Kettle Brook on the banks of the Connecticut River. After the new gristmill was built, the 1784 gristmill served as a storeroom in the C. H. Dexter paper plant until 1898, when it was torn down to make room for a new brick stockroom. (DRC, C. H. Dexter Company Records.)

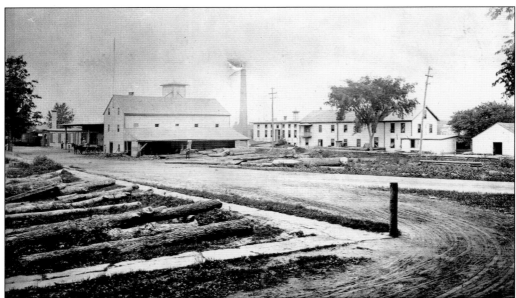

Shown here is another view of the gristmill. At the time this photograph was taken in 1909, the building housed a flourishing flour, grain, and feed business as well as a sawmill. Here flour and meal was ground for local farmers, and later the mill did wholesale grinding for the Springfield, Hartford, and New Haven markets. The gristmill was a landmark in the town of Windsor Locks until its demolition in 1925. (DRC, C. H. Dexter Company Records.)

An early-19th-century portrait of Seth Dexter is reproduced here. In 1784, Dexter expanded the sawmill his father had purchased on the banks of the Connecticut River in 1767 into a gristmill. (DRC, C. H. Dexter Company Records.)

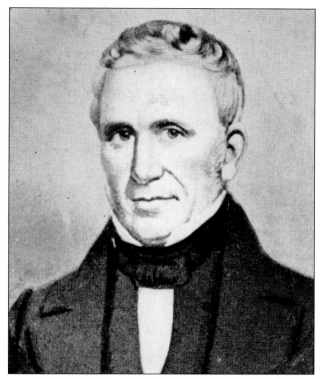

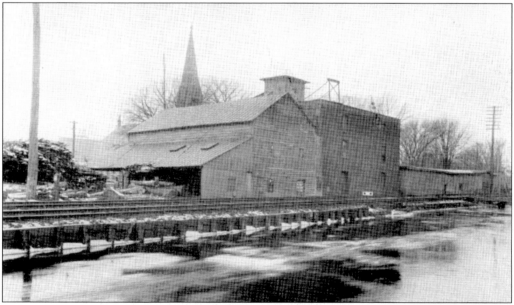

This c. 1900 photograph shows the back (canal side) of the grist- and sawmill. In this building, Seth Dexter's son Charles Haskell Dexter began to produce handmade manila wrappers, using manila hemp rope for pulp. In 1840, Charles moved his paper manufacturing activities to a frame building across the canal from the gristmill and named his business C. H. Dexter and Company. (KML.)

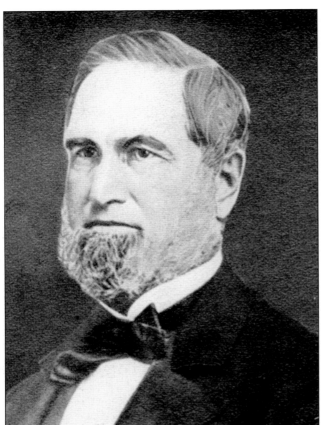

This is a *c.* 1860 portrait of Charles Haskell Dexter. (DRC, C. H. Dexter Company Records.)

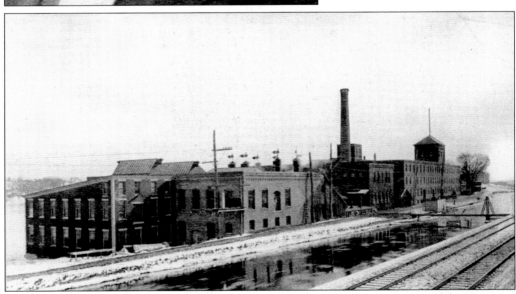

The original Dexter company paper mill was destroyed by fire in 1875, but a new mill building was erected in 1875 and it formed the nucleus of the extensive plant shown in this 1915 photograph. (DRC, C. H. Dexter Company Records.)

This is a *c.* 1880 portrait of Edwin D. Dexter. In 1867, Charles's son Edwin D. Dexter and son-in-law Herbert R. Coffin joined the firm, and the company became C. H. Dexter and Sons. Charles died in 1869, and the business continued under the management of Edwin and Herbert. (DRC, C. H. Dexter Company Records.)

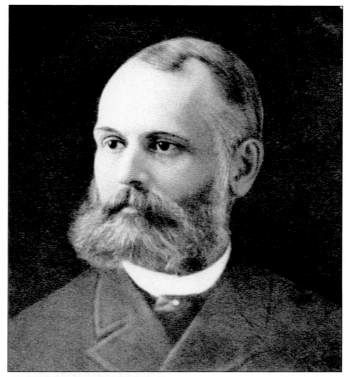

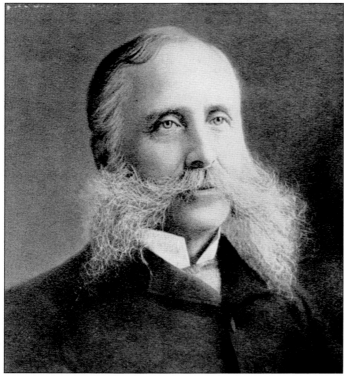

Shown here is a *c.* 1880 portrait of Herbert R. Coffin. With the death of Edwin D. Dexter in 1886, Coffin assumed full ownership and management of the papermaking business started by Charles H. Dexter, continuing the old name of C. H. Dexter and Sons. (DRC, C. H. Dexter Company Records.)

SEVENTY-FIRST

ANNUAL REPORT ❧ DIRECTORS

TO THE

STOCKHOLDERS

OF THE

Connecticut River Company,

JANUARY 22, 1895.

—◆—

OFFICERS ELECTED FOR 1895.

PRESIDENT,

HERBERT R. COFFIN.

TREASURER AND SECRETARY,

MILES W. GRAVES.

BOARD OF DIRECTORS,

SAMUEL H. ALLEN,	MILES W. GRAVES,
HERBERT R. COFFIN,	PINCKNEY W. ELLSWORTH,
SAMUEL E. ELMORE,	B. ROWLAND ALLEN,
J. R. MONTGOMERY,	EZRA B. BAILEY,

H. W. ERVING.

EXECUTIVE COMMITTEE,

SAMUEL E. ELMORE, EZRA B. BAILEY.

AUDITORS,

SAMUEL E. ELMORE, B. ROWLAND ALLEN,

COMMISSIONERS.

GEORGE G. SILL, WILLIAM M. HUDSON,

JOHN B. MOSELEY.

Herbert R. Coffin, president of C. H. Dexter and Sons, was also president of the Connecticut River Company, which operated the Windsor Locks Canal. Reproduced here is the cover page of the 1895 annual report to the stockholders of the Connecticut River Company. (DRC, C. H. Dexter Company Records.)

Report for Year Ending January 1st, 1895.

RECEIPTS, 1894.

Cash on hand January 23, 1894,	$ 199.48
Water Rents from Leases,	13,659.30
" " Extra Water,	9,202.49
Tolls,	9.00
Land Rents,	50.00
Tenements,	339.20
Loans from Sundry Parties,	38,600.00
	$62,059.47

DISBURSEMENTS, 1894.

Interest on Loans,	$2,491.73
Ordinary Expenses,	5,338.72
Repair Lower Cotton Mill,	6,930.77
Repair Dam and Aqueduct,	2,814.43
Banks, Bridges and Boats,	1,961.98
Repair Lower Locks,	1,421.64
" Feeder Gates,	304.29
Cash on hand January 22, 1895,	66.77
Cash paid for Real Estate,	3,229.74
Loans Paid,	37,500.00
	$62,059.47

We, the undersigned, have examined the accounts of Receipts and Disbursements, and compared them with the vouchers and other documents and find them as stated in the Report.

SAMUEL E. ELMORE, }
B. ROWLAND ALLEN, } *Auditors.*

It was originally anticipated that a large share of the income of the Connecticut River Company would be derived from tolls collected from vessels as they passed through the canal's locks. But, as its annual report here shows, the company only received $9 from tolls in 1894. The income from rents for water leases and extra water, however, was almost $23,000, proving the wisdom of the canal proponents in designing the canal not only to facilitate steamship transportation but also to provide waterpower for manufacturing purposes. (DRC, C. H. Dexter Company Records.)

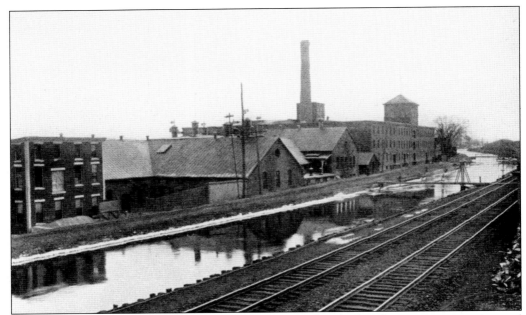

When this photograph was taken in 1909, the Dexter plant had undergone an expansion and was comprised of several buildings. During the early 1900s, the paper company specialized in high-grade catalog and booklet cover papers. After Herbert R. Coffin's death in 1901, his sons, Arthur and Herbert, took charge of the Dexter company. (KML.)

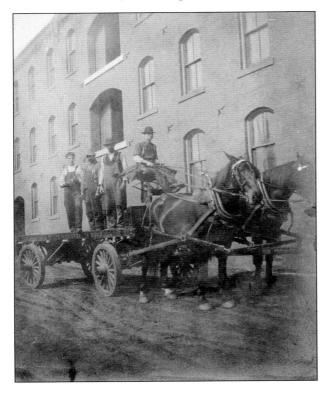

This *c.* 1900 photograph shows a delivery wagon in front of the Dexter building. Note the stars on the building. The Dexter plant was referred to as the "Star Mills" because the company had the exclusive right to use the star trademark on paper of any kind. The stars on the building are a reference to the Dexter star trademark. (DRC, C. H. Dexter Company Records.)

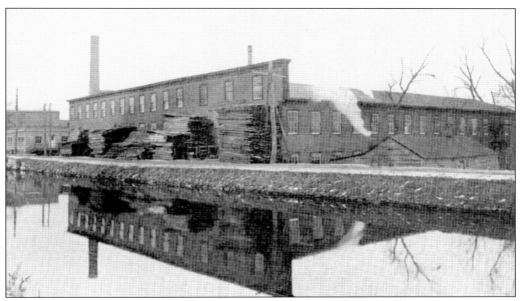

Pictured here in this *c.* 1909 image is the George P. Clark Company, which produced hand, platform, and special trucks. The trucks were made in a large variety of styles, suitable for moving all kinds of material. George P. Clark invented and patented a method of attaching rubber tires to iron truck wheels, which became a valuable feature of the business. (KML.)

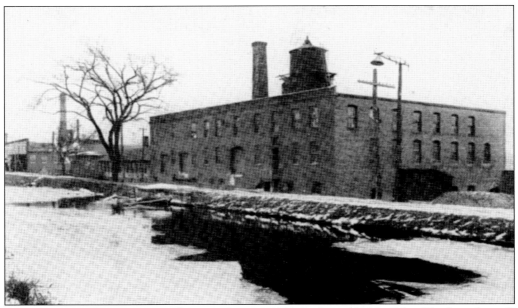

The Windsor Silk Company mill is seen here in 1909. Built in 1838 by Jabez Hayden, the mill was one of the first manufacturers of silk textiles in Connecticut. (KML.)

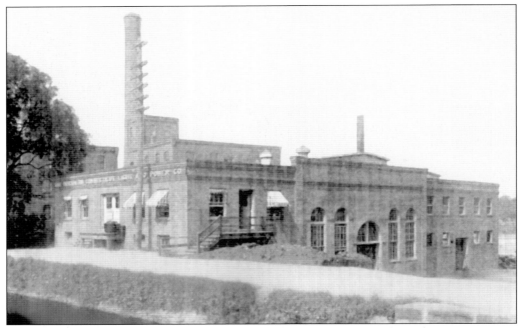

This photograph was taken shortly after the Northern Connecticut Light and Power Company plant was built in 1907. The company purchased and consolidated the local electric lighting companies in Windsor Locks and Enfield. The plant produced electricity, and gas was piped in from Hartford. (KML.)

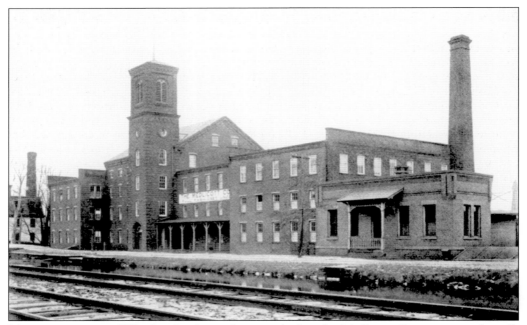

Many generations of Windsor Locks residents worked at the Medlicott Company textile mill, which produced knit clothing. Built in 1863, the mill was located on the canal bank next to the suspension bridge. (KML.)

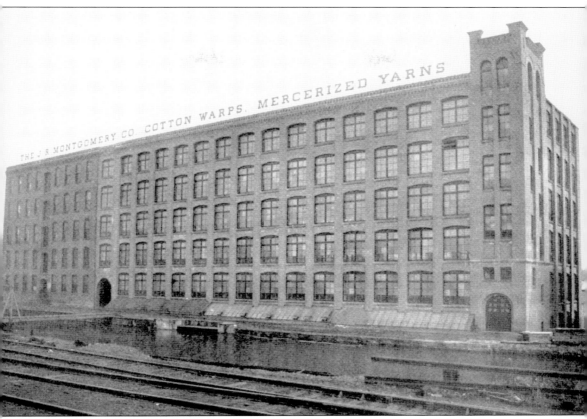

The first part of the J. R. Montgomery Company building, shown here in this 1909 photograph, was erected in 1891 and was known as the No. 1 or north mill. The mill expanded in 1904 with the construction of the much larger No. 2 mill, which was joined to the No. 1 mill's south wall. Another concrete building was added to this brick structure on its south side in 1920. Established in 1871, the J. R. Montgomery Company had a long history in the town of Windsor Locks. In 1896, it was the first company in the United States to market an entirely new product, mercerized cotton yarn. It also produced cotton warp and novelty yarns. In the 1880s, metal or tinsel yarns were manufactured. In 1905, these tinsels found a new use in communication equipment such as telephones. In the 1930s, the textiles were replaced with tinsel thread and cord manufacturing. In the following decades, wiring for telephone cables, electric cords, and appliances was produced. The firm continued in business in Windsor Locks until 1989. (KML.)

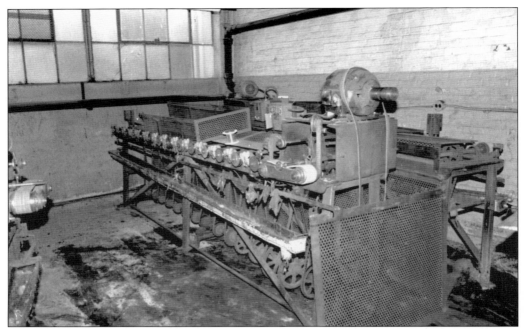

In this view dated 1989, a wire-drawing machine that was designed by the Montgomery Company and made in Germany in 1899 is shown. The machine drew copper wire through a series of dies of ever-decreasing diameter to a predetermined gauge. (DRC, Connecticut Historic Preservation Collection.)

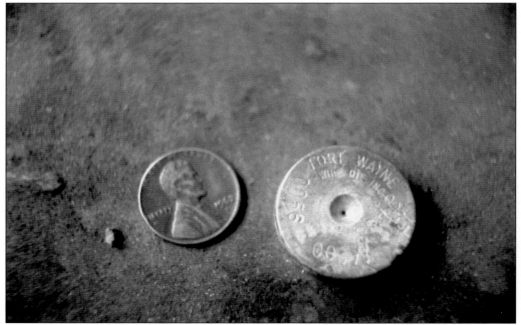

This 1989 photograph shows a die, called a diamond die, used in the wire-drawing machine pictured in the previous image. (DRC, Connecticut Historic Preservation Collection.)

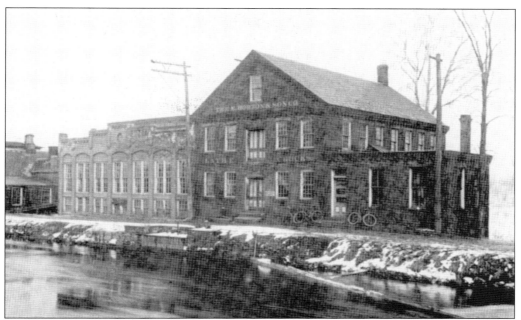

In 1855, the inventor of the Horton universal chuck, Eli Horton, started a business making chucks in sizes suitable for holding the smallest drill to the largest wheel at his plant on the canal bank. An addition was constructed in 1903, doubling the capacity of the plant. Notice the bicycles parked near the door, a practical and inexpensive mode of travel for workers, in this c. 1905 image. (KML.)

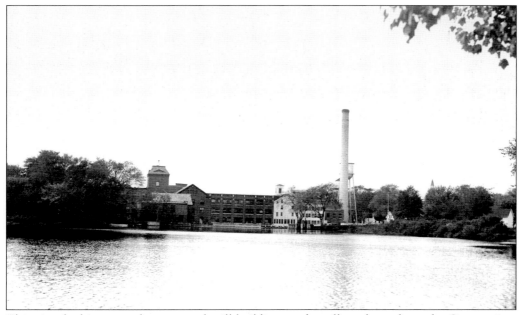

This view looking west shows several mill buildings and a tall smokestack on the Connecticut River in Windsor Locks in 1948. Notice the river is very placid, indicating that this photograph was likely taken in midsummer. (DRC, Southern New England Telephone Company Records.)

Reproduced here is the cover from the 22nd issue of the Dexter house publication, *XTRA*, published in 1918. For many years, *XTRA* was designed and written by Howard Marcus Strong. (DRC, C. H. Dexter Company Records.)

This 1918 advertisement sings the praises of Dexter's Star Manifold Linen paper used to make carbon copies. Advertising was an important part of the papermaker's business. (DRC, C. H. Dexter Company Records.)

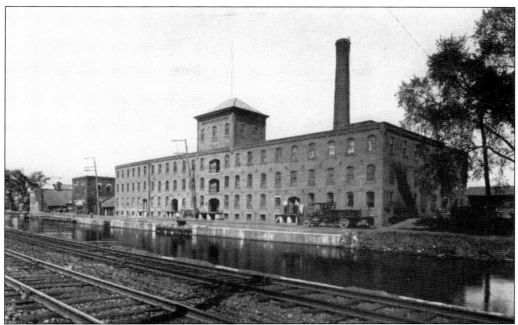

This *c.* 1918 image shows the Dexter mill complex from the canal level. Notice one of the company's delivery trucks is parked near the loading dock. The plant was built with the canal on one side and the river 30 feet below on the other. This resulted in structures that towered many stories high when viewed from the surface of the Connecticut River but in some instances barely topped the rise on the canal side. (DRC, C. H. Dexter Company Records.)

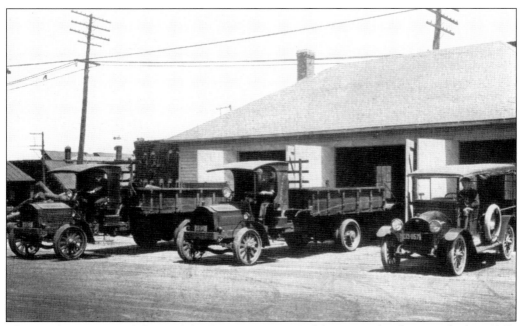

This is a better view of three of the Dexter company's delivery trucks photographed in 1918. (DRC, C. H. Dexter Company Records.)

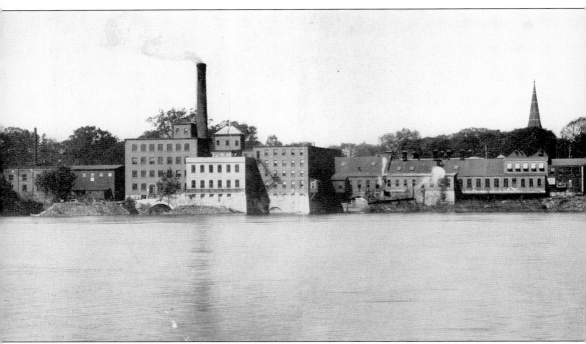

This image was a double-page illustration printed in the 1918 Dexter *XTRA* booklet. It was the first photograph of the Dexter mills ever taken from across the Connecticut River and gives a more comprehensive idea of the size of the plant than any views from the canal side. (DRC, C. H. Dexter Company Records.)

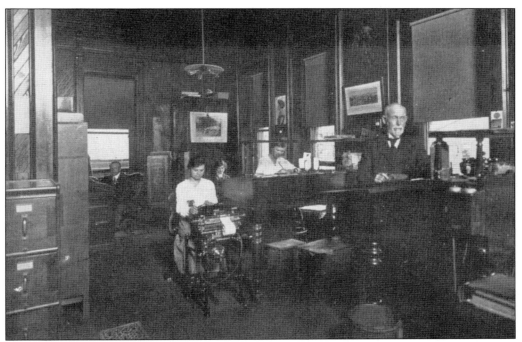

The accounting department at the Dexter company is shown here in this *c.* 1918 photograph. Notice the machine the young lady is using. (DRC, C. H. Dexter Company Records.)

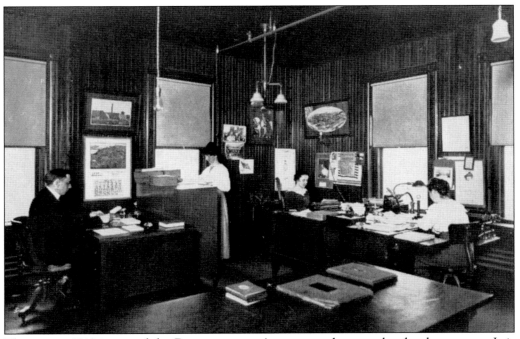

This is a *c.* 1918 image of the Dexter company's correspondence and order department. It is interesting to note the number of women who worked for the company, even in 1918. Notice the large number of decorations on the office walls. (DRC, C. H. Dexter Company Records.)

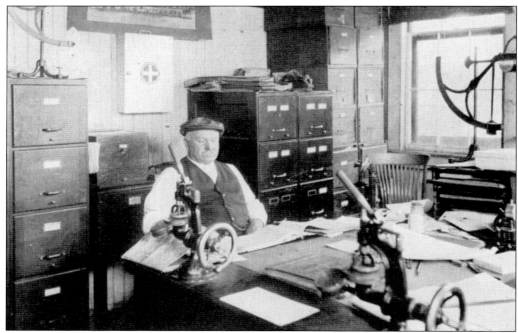

Dexter company superintendent John Leishman was photographed in his office in 1918. Leishman would have been in charge of day-to-day operations at the mill. (DRC, C. H. Dexter Company Records.)

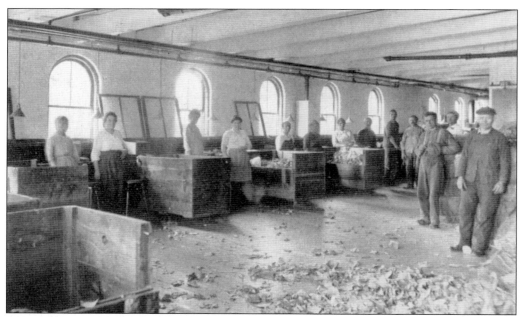

Pictured here is the rag room of the Dexter mill, where workers sorted the cloth remnants that would be used in producing the company's different paper products. Notice that the workers appear to be evenly divided between men and women in this c. 1918 photograph. (DRC, C. H. Dexter Company Records)

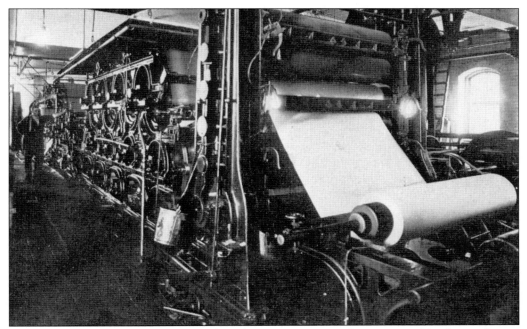

The machine in this c. 1918 image made carbon tissue paper and was operated by the gentleman standing next to the machine. Although during the mid-1800s paper was still predominantly made by hand, one sheet at a time, there were efforts to produce machines that could manufacture paper. The first continuous papermaking device was patented in 1798. The invention was improved by Henry and Sealy Fourdrinier in the 19th century and inspired the invention and production of other fourdrinier machines in the United States. Sections of giant paper machines today are still called fourdriniers. (DRC, C. H. Dexter Company Records.)

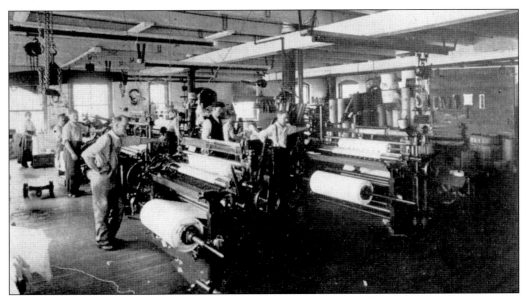

The rewinding room at the Dexter mill, where paper would be wound into rolls of various sizes, is pictured here in this 1918 photograph. (DRC, C. H. Dexter Company Records.)

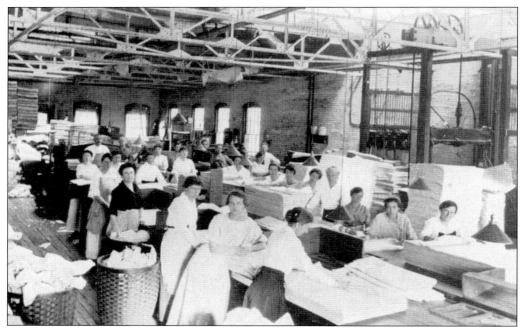

In the finishing room, the paper would be inspected, sorted, and packaged in ream lots and counted for shipment. (DRC, C. H. Dexter Company Records.)

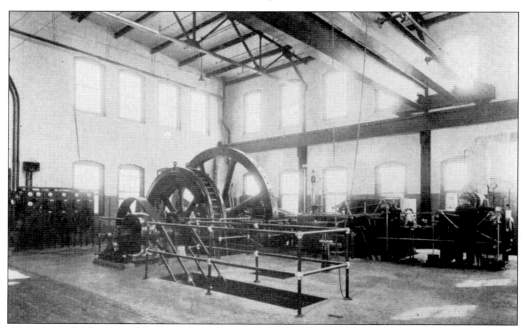

This is a c. 1918 view of the Dexter mill engine room and electric generators. During the early 1900s, the mill occasionally had to stop production due to power outages during severe winter weather. Frigid temperatures caused the water in the canal to freeze, preventing it from being used to power the plant. The addition of a large engine and electric generators made the mill immune to power outages caused by severe weather. (DRC, C. H. Dexter Company Records.)

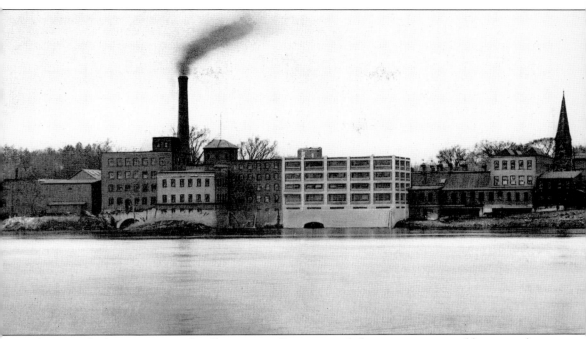

This view looks west across the Connecticut River toward the new concrete addition to the Dexter mill, located in the center of the photograph. The addition was completed in 1924. (DRC, C. H. Dexter Company Records.)

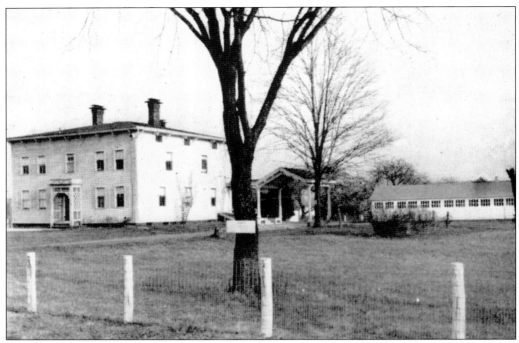

In 1923, the Dexter company purchased a home in Windsor Locks and converted it to a boardinghouse for single male workers at the mill. (DRC, C. H. Dexter Company Records.)

A 1915 portrait of Herbert R. Coffin (the second) is shown here. C. H. Dexter and Sons became an incorporated organization in 1914, with Arthur D. Coffin as its president and Herbert R. Coffin as vice president. (DRC, C. H. Dexter Company Records.)

Issued in 1928, this Dexter *XTRA* cover shows the front of the new addition to the Dexter mill featuring the tower, with an illuminated clock and a door flanked by bronze nameplates and lanterns, and a bronze marquee overhead. (DRC, C. H. Dexter Company Records.)

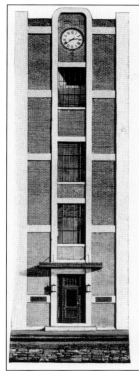

DEXTER'S XTRA

★

EDITED BY MARCUS

★

No. 60

★

CONTAINING NOTES ON THE NEW ADDITION

★

ISSUED BY
C. H. DEXTER & SONS
INCORPORATED
WINDSOR LOCKS, CONN.

Dexstar Tissue Papers

For Decoration, Artificial Flowers and Dainty Gift Wrapping

For Protecting Silverware and Polished Surfaces from Tarnish

For Conversion Purposes, such as Carbon Papers

For Insulating in Electrical and Radio Construction

C. H. DEXTER & SONS, Inc.
Highest Grade Thin Papers
WINDSOR LOCKS, CONN.

This 1928 advertisement promotes the use of Dexstar tissue paper for gift wrapping a very "of-the-moment" but fragile perfume bottle. (DRC, C. H. Dexter Company Records.)

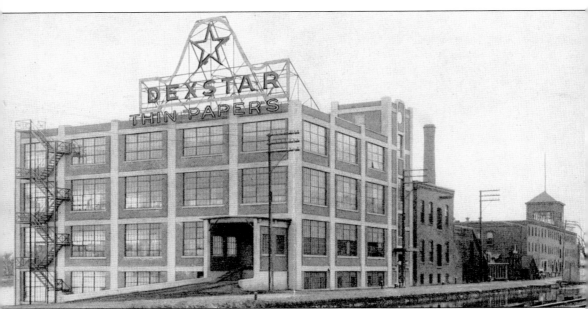

In January 1928, a reception was held to celebrate the completion of the newest addition to the Dexter mill, shown in this photograph taken the same year. The annex was of reinforced concrete with redbrick-filled bays. On the north side of the roof of the addition was placed a large illuminated Dexstar sign with letters four feet high. Because the original star trademark of the company was constantly infringed upon, a new trademark was coined—Dexstar—a combination that united the firm name and old star trademark. (DRC, C. H. Dexter Company Records.)

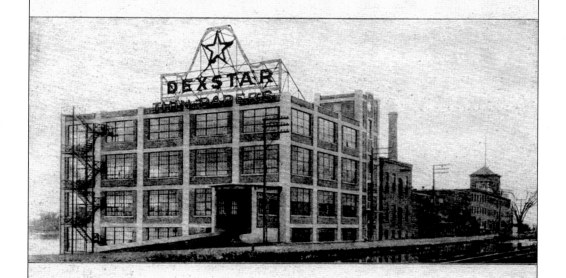

1835 ★ 1935
DEXSTAR

A CENTURY OF PAPER MAKING

C. H. DEXTER & SONS, INC.
HIGH GRADE THIN PAPERS
WINDSOR LOCKS, CONN.

Reproduced here is a 1935 Dexter company advertisement that prominently displays the Dexstar trademark above a picture of the new annex. (DRC, C. H. Dexter Company Records.)

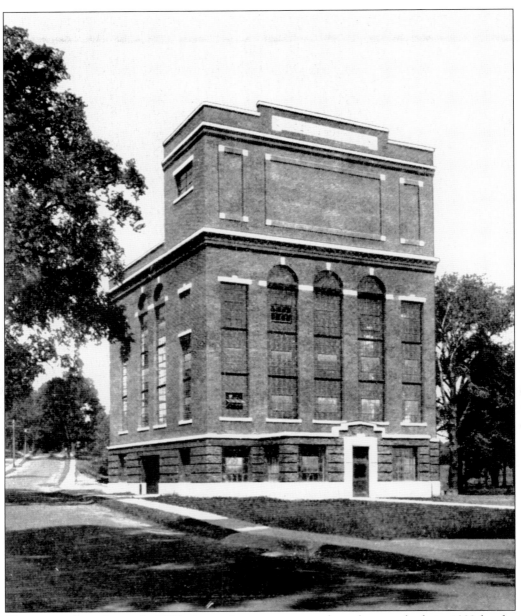

This image from the early 1930s shows the steam power plant that was built in 1929 by the Dexter company. The power plant, which was considered very modern in 1929, was located across the canal from the mill complex on the corner of Main and Elm Streets in Windsor Locks. In 1964, the power plant was torn down and replaced by Dexter's corporate headquarters. (DRC, C. H. Dexter Company Records.)

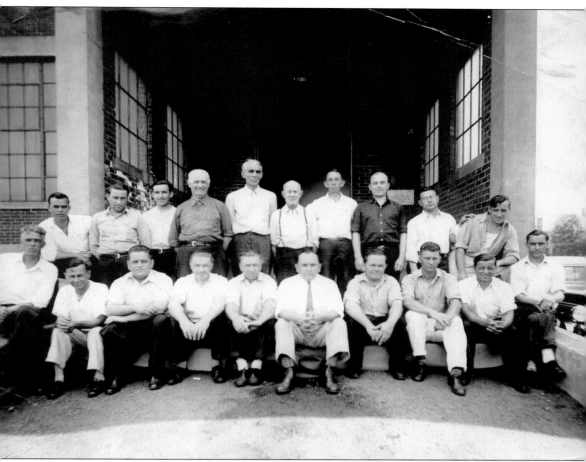

Dexter company employees assembled for this c. 1940 photograph taken in front of the 1928 addition. Notice the automobile parked on the right. (DRC, C. H. Dexter Company Records.)

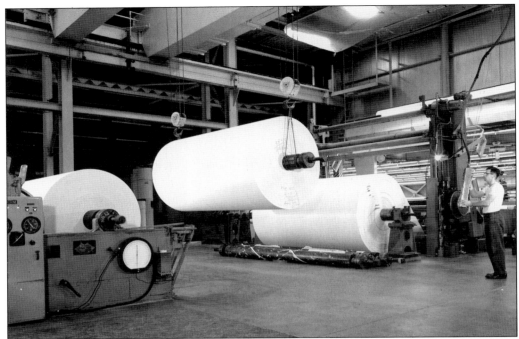

This photograph from the 1950s shows a machine at the Dexter mill winding a large roll of uncut paper. (DRC, C. H. Dexter Company Records.)

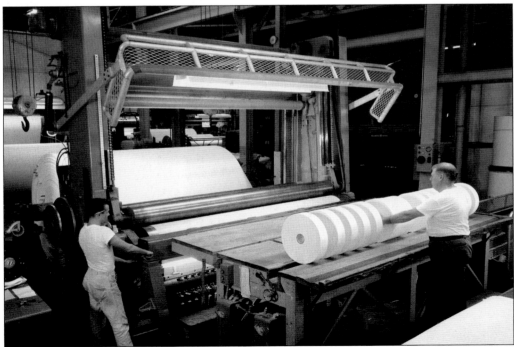

In this photograph from the same time period as the previous image, the large roll of paper is being cut into smaller rolls. (DRC, C. H. Dexter Company Records.)

Four

THE CANAL THROUGH THE DECADES

This photograph was taken in 1918 during a typical midwinter freeze of the canal. Ice in the canal and river could spell trouble for local mills, depriving them of the water that powered their operations or was used in their manufacturing processes. (DRC, C. H. Dexter Company Records.)

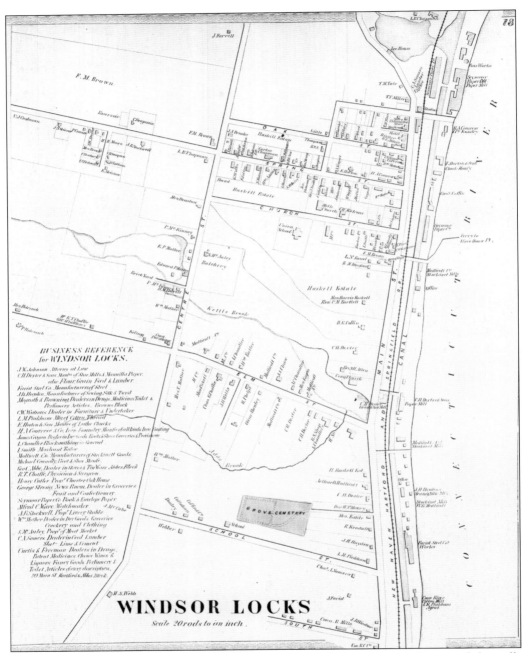

WINDSOR LOCKS

Scale 20 rods to an inch.

This c. 1867 map of the town of Windsor Locks shows residences, property lines, and the mills along the canal and includes a business reference. Notice that most of the churches, stores, homes, and manufacturing establishments in town, as well as the railroad station and freight depot, are within a stone's throw of the canal. (HBL.)

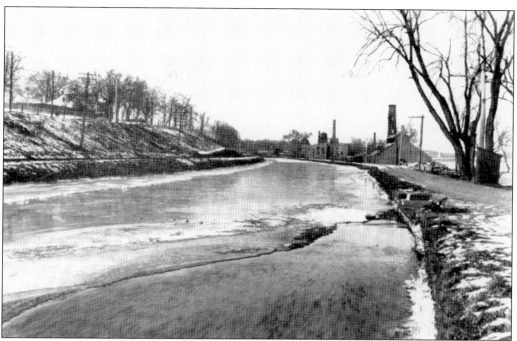

This view looking north shows the lower end of the canal about 1909. The first building is a steel mill that produced cutlery. (KML.)

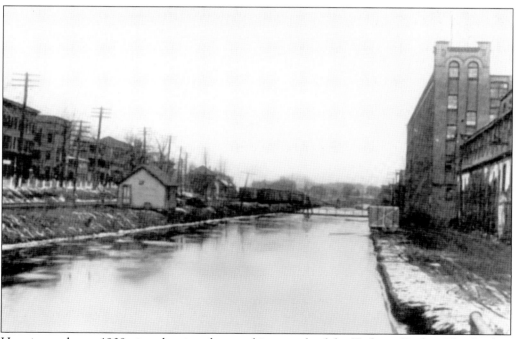

Here is another c. 1909 view showing the canal just north of the Highway Bridge. The Anchor Mills Paper Company and the Montgomery Company can be seen to the right, and Main Street in Windsor Locks is on the left. (KML.)

This photograph of the 1928 addition to the Dexter mill was likely taken in the 1940s.

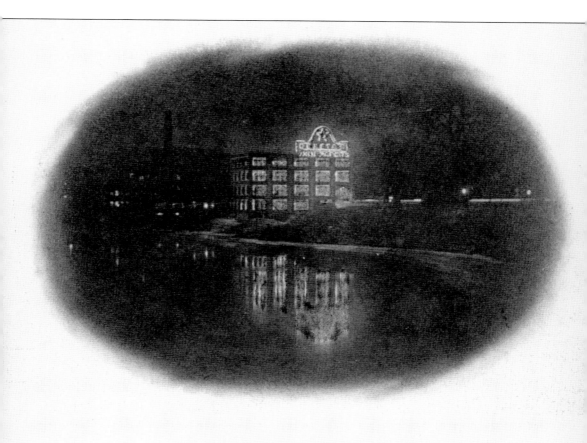

NIGHT VIEW OF NEW ADDITION TO MILLS OF

C. H. DEXTER & SONS, Inc.

WINDSOR LOCKS, CONN.

Shown here is a night view of the addition to the Dexter plant with its illuminated sign. The image was published in a 1928 Dexter publication. The photographer was likely standing on the bridge over the Connecticut River north of the Dexter mill when he or she snapped this picture. (DRC, C. H. Dexter Company Records.)

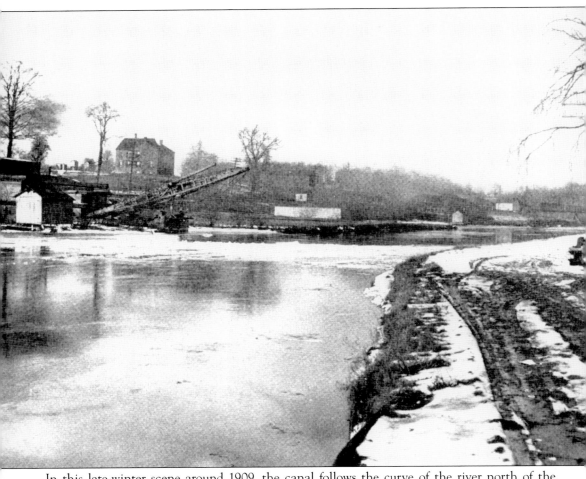

In this late-winter scene around 1909, the canal follows the curve of the river north of the Windsor Paper Company. (KML.)

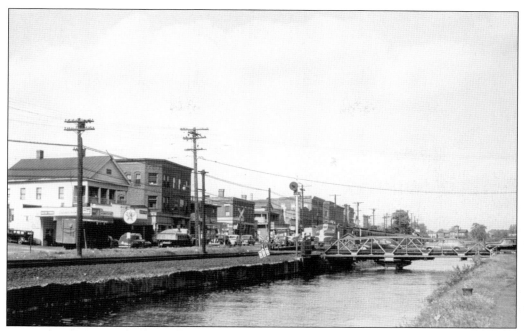

Pictured in this 1948 photograph are automobiles and a truck in front of businesses, including a gas station, along Main Street in Windsor Locks. Notice that three automobiles are stopped on the one-lane canal bridge waiting for a southbound train to pass by. (DRC, Southern New England Telephone Company Records.)

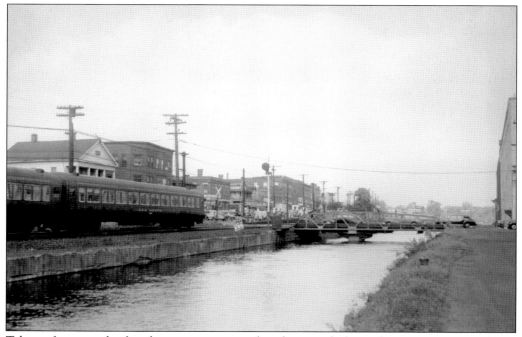

Taken a few seconds after the previous image, this photograph shows the passenger train after it has cleared the canal bridge. (DRC, Southern New England Telephone Company Records.)

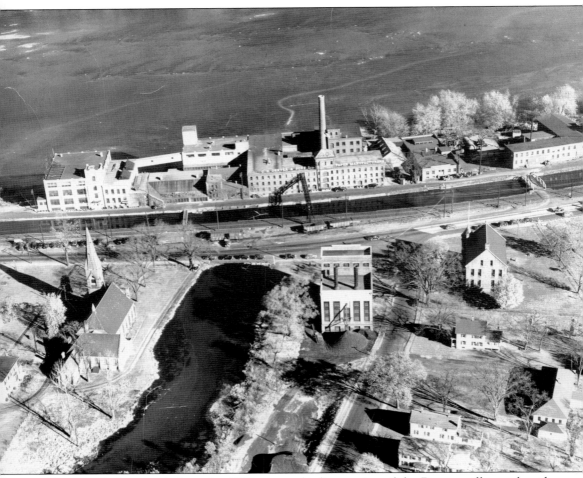

This aerial photograph from the 1950s gives a bird's-eye view of the Dexter mill complex, the steam power plant, the canal, and the Connecticut River. Notice the "C. H. Dexter & Sons Inc. Paper Manufacturers" on top of the building in front of the tall smokestack. Soldiers Memorial Hall is on the right at the corner of Main and Elm Streets, opposite the steam power plant. The Congregational church is located next to Mill Pond. Kettle Brook had been dammed to form Mill Pond, which was the setting for many fishing derbies over the years. (DRC, C. H. Dexter Company Records.)

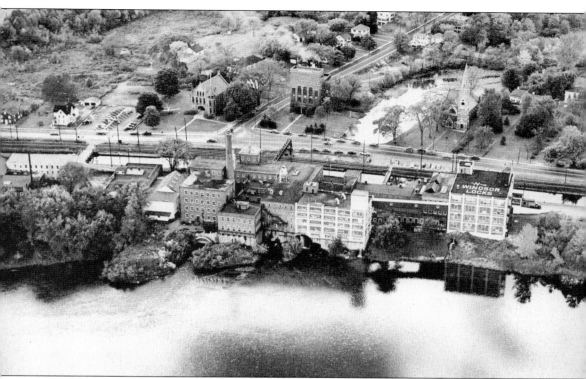

In this 1954 overhead view looking west, the extensive Dexter mill complex can be seen. Notice "Windsor Locks" painted on the top of the building on the right. (DRC, C. H. Dexter Company Records.)

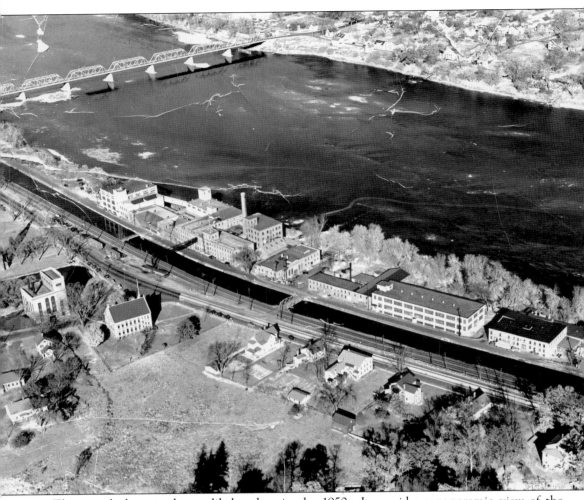

This aerial photograph was likely taken in the 1950s. It provides a panoramic view of the truss bridge, the mills along the canal, Soldiers Memorial Hall, the Connecticut River, and Warehouse Point. The river is a formidable presence in this picture. (DRC, C. H. Dexter Company Records.)

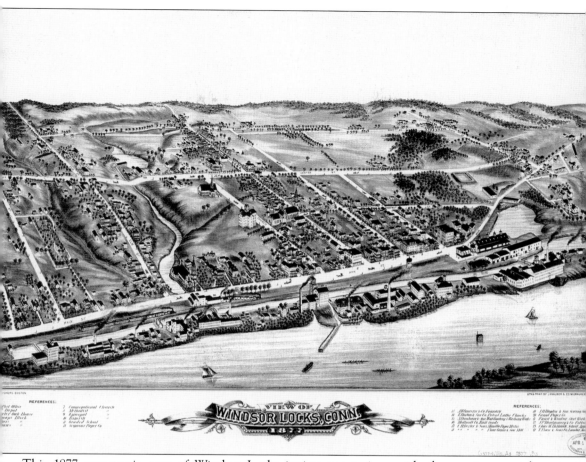

This 1877 panoramic map of Windsor Locks invites comparison with the previous aerial photograph from the 1950s. The map is indexed for points of interest. The Congregational church, which was built in 1847, is located next to Mill Pond. However, Soldiers Memorial Hall was not completed until 1891 and therefore is not included on the map. Notice the long pier or wharf that extends out into the Connecticut River. The pier was built out from the west shore to the deeper channel so that when the river was low, the ferryboat could still pick up and drop off passengers at the end of the pier. (LC.)

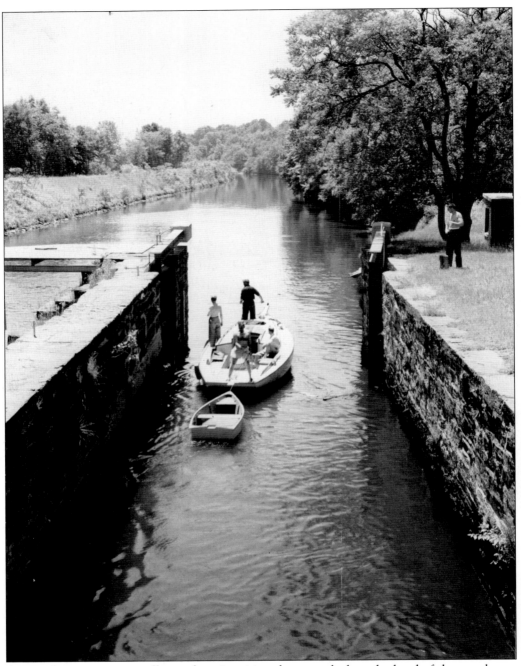

A motorboat towing a smaller rowboat is exiting the upper lock at the head of the canal on a June day in 1952. (DRC, Southern New England Telephone Company Records.)

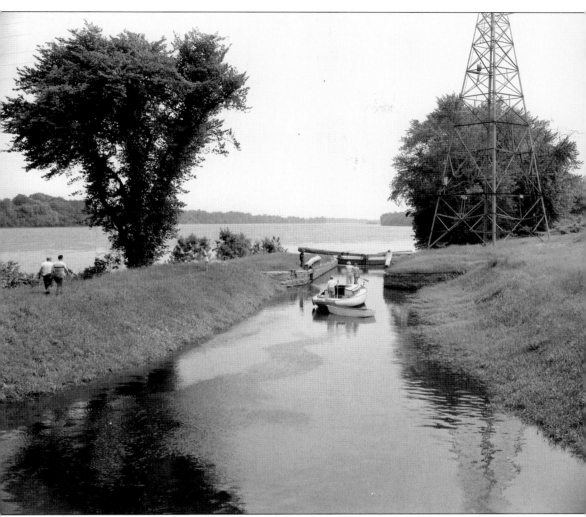

Here the same boat pictured in the previous image is waiting for the gates of the lower lock at Windsor Locks to open before heading downstream on the Connecticut River. (DRC, Southern New England Telephone Company Records.)

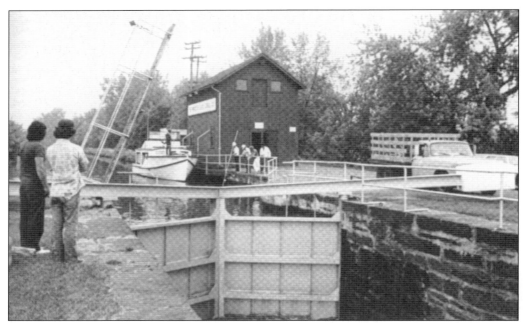

A *c.* 1975 photograph shows a boat locking through the lower end of the canal. Notice the lock gates, which are made of steel and have steel balance beams with concrete counterweights. A wooden valve house can be seen in the background.

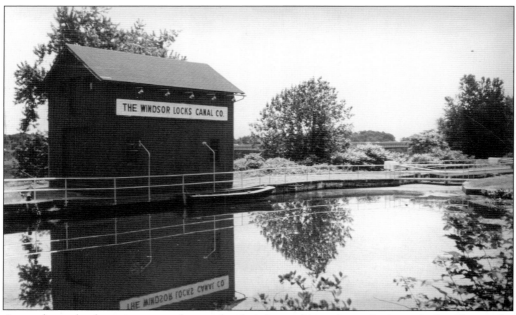

A wooden valve house to control water levels is located just above the lower locks. Notice the words "The Windsor Locks Canal Co." painted on the side of the valve house. The canal is owned and operated by the Windsor Locks Canal Company. Formerly owned by C. H. Dexter and Sons, the canal company was acquired by Ahlstrom-Windsor Locks LLC when the Dexter mill was purchased by the Ahlstrom Corporation in 2000. (DRC, C. H. Dexter Company Records.)

This overhead view depicts the Dexter corporate headquarters, built in 1964 on the site of the former steam plant. Notice that Mill Pond next to the Congregational church is gone. The pond had to be drained to accommodate the new building, but Kettle Brook still continues to flow. A year later, the company continued to expand with the addition of a research and development center on Elm Street located just behind Soldiers Memorial Hall. (DRC, C. H. Dexter Company Records.)

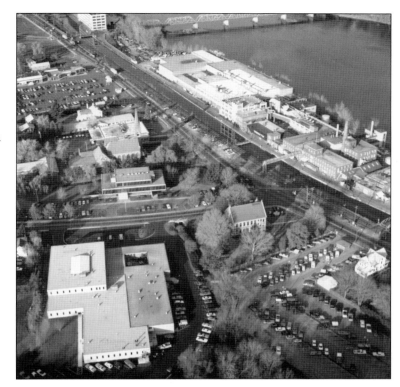

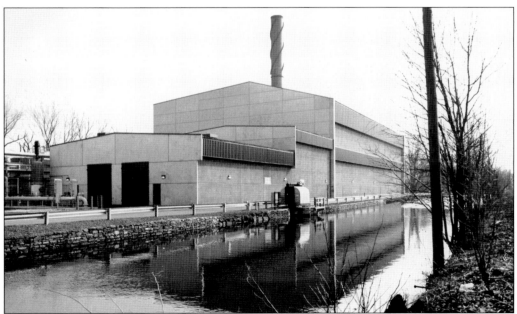

Shown here is Algonquin Power's Windsor Locks cogeneration facility, which was commissioned in 1990. The facility delivers thermal steam energy and a portion of its electrical generation to the Ahlstrom (formerly Dexter) mills located next to the generating station. (DRC, C. H. Dexter Company Records.)

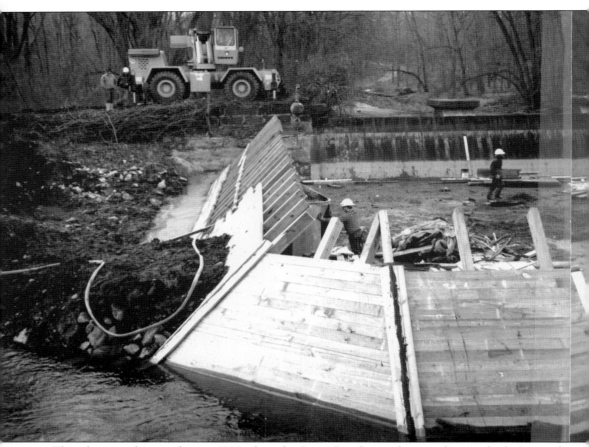

This photograph was taken in 1998 when the Stony Brook aqueduct was being rebuilt. Located two miles downstream of the Enfield Dam, the aqueduct carries the Windsor Locks Canal over the 102-foot-wide crossing of Stony Brook. The aqueduct was rebuilt to two-thirds of its original width (on the west side) using new concrete decking and side walls placed atop the original masonry piers. The remaining (eastern) third of the original timber aqueduct was left in place (along with the towpath bridge) to preserve the historic nature of the structure. Until rebuilt in 1998, this aqueduct was the last masonry pier, wood trunk, navigation aqueduct in service

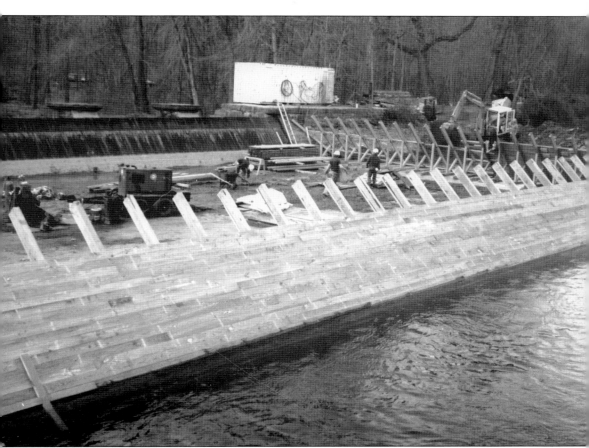

in the Northeast. Originally constructed in 1828, the structure consisted of four piers and two abutments built from native sandstone. The piers and abutments supported heavy timber beams strung approximately six feet above Stony Brook and decked over with timber planks. The aqueduct was trapezoidal shaped, approximately 100 feet long and 60 feet wide with 10-foot-high walls sloped at 45 degrees. A towpath bridge for horses and mules ran parallel with the aqueduct (on the east side). (DRC, C. H. Dexter Company Records.)

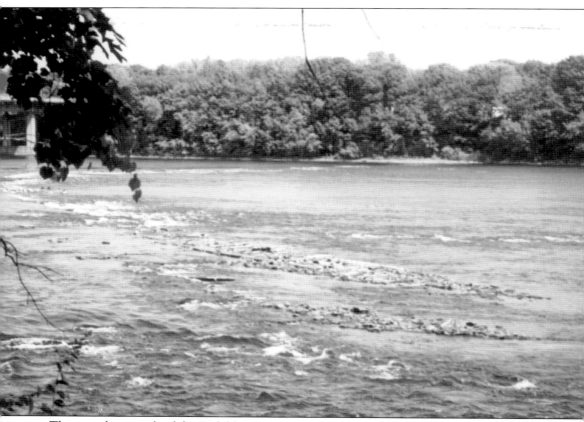

This is a photograph of the Enfield Dam taken in 2006, over 150 years after it was built. Nearly 1,500 feet long, the dam spans the Connecticut River just south of the Route 190 bridge between Suffield and Enfield. The dam fell into disrepair in the late 1970s and is now breached in many areas. As a result, the water level above the dam has dropped. The dam is owned by Ahlstrom-Windsor Locks LLC. (MR.)

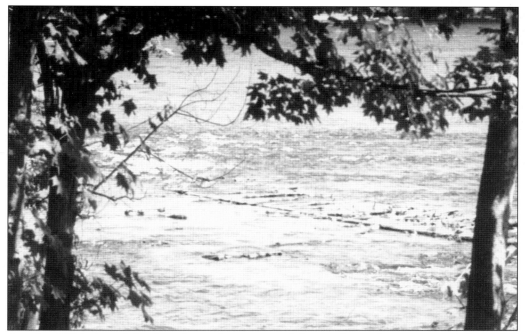

Another 2006 view of the dam shows the remains of the wooden crib structure and the stones used to fill the cribs. The wood cribs are now mostly rotted. (MR.)

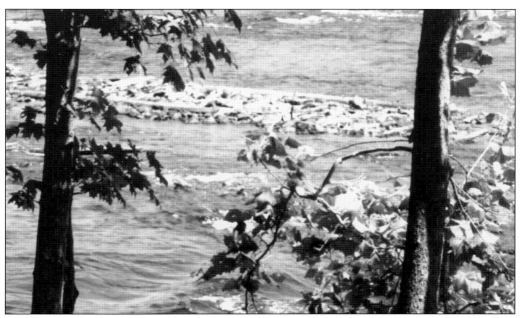

This close-up view is of the timber and rocks of the dam's collapsed crib structure. The collapse of the dam has increased the number of migratory fish, such as shad, salmon, river herring, and shortnose sturgeon, that swim upriver to spawn. Before the Enfield Dam was breached, shad fishermen had to fish south of the dam. Now they are able to fish for shad below the Holyoke, Massachusetts, dam. (MR.)

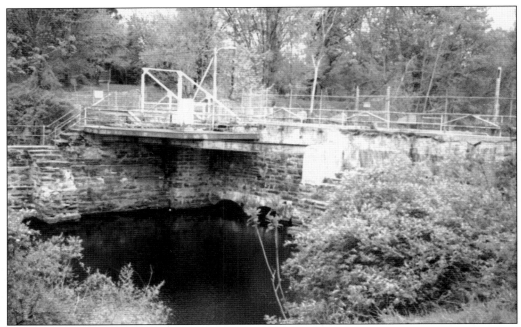

This 2006 photograph shows the guard lock (20 feet by 91 feet) and breast wall at the upper (Suffield) end of the canal. The masonry breast wall has 12 sluices with sliding gates to allow the flow of water for hydraulic purposes. (MR.)

The guard lock controls the flow of water into the canal, protecting the canal even if the river rises. A steel drawbridge spans the lock entrance just above the upper gates. The entrance is now blocked by a concrete plug. (MR.)

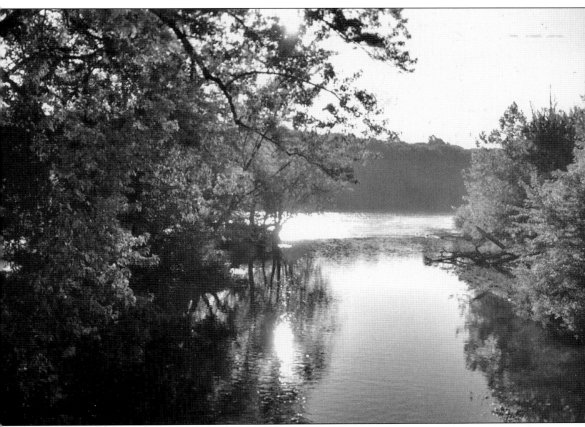

Pictured here is an early-morning view of Stony Brook as it flows into the scenic Connecticut River. The photograph was taken in the late summer of 2005 from the towpath bridge on the aqueduct—the author's favorite stopping place along the canal. King's Island can be seen in the distance.

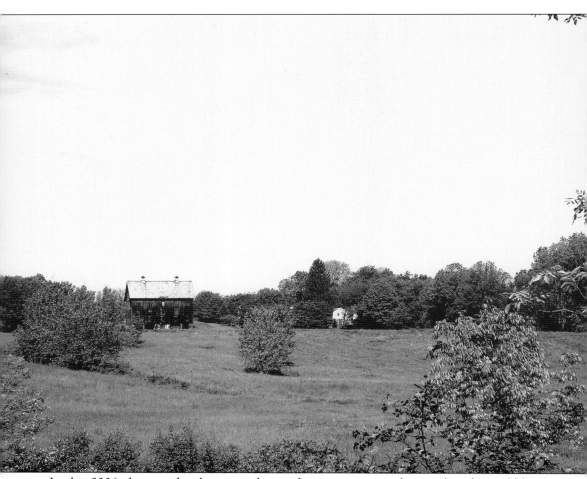

In this 2006 photograph taken near the northern entrance to the canal trail, an old barn is shown on a gently sloping hillside, a visual reminder of the beauty of the Connecticut River Valley. (JG.)

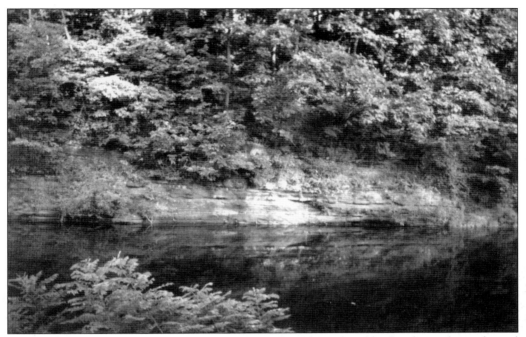

A close-up view of the west bank of the canal north of the railroad bridge shows the geological deposits of sandstone that can be seen along the banks of the canal and river as well as on King's Island.

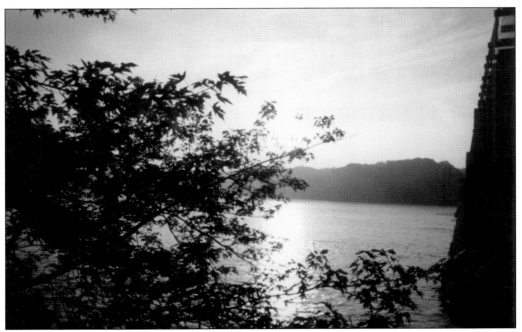

Here streams of sunlight glance off the surface of the river shortly after sunrise in early summer 2005. The author took this photograph standing on the canal towpath just north of the railroad bridge, looking east.

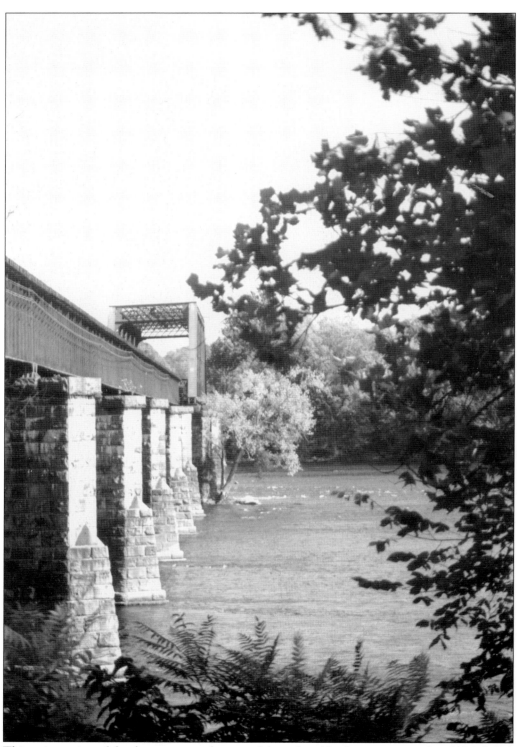

This unique view of the downstream-side piers of the railroad bridge was captured in 2004. (MR.)

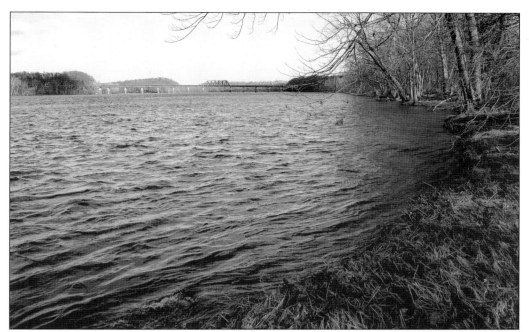

This sweeping view shows the beautiful curve of the Connecticut River about a mile south of the railroad bridge. The railroad bridge, which was built in 1903, is visible in the distance. The photograph was taken from the east bank of the river in November 2006. (JG.)

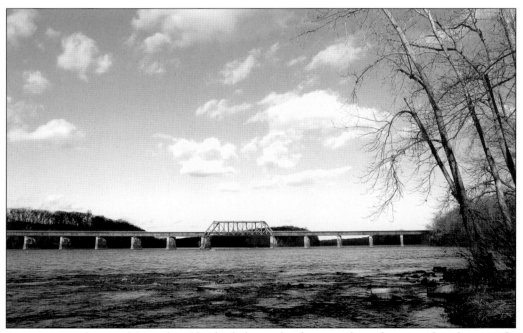

An exceptional view of the railroad bridge below a cloud-strewn sky is shown in this photograph, also taken from the east bank of the river in November 2006. The picture was taken about a half mile south of the bridge and shows its downstream side. (JG.)

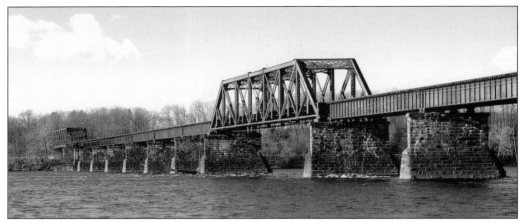

This photograph of the railroad bridge was taken at an angle and offers a closer view of the piers' sloped masonry icebreakers on the upstream (northern) side. Notice the dead tree caught at the base of the downstream side of one of the piers. (JG.)

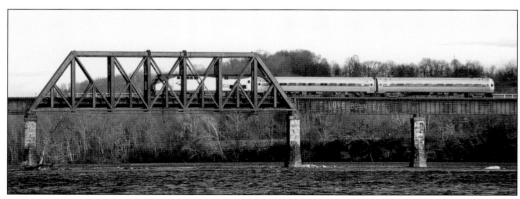

An Amtrak passenger train is shown passing over the railroad bridge in this November 2006 view looking north from the east bank of the river. (JG.)

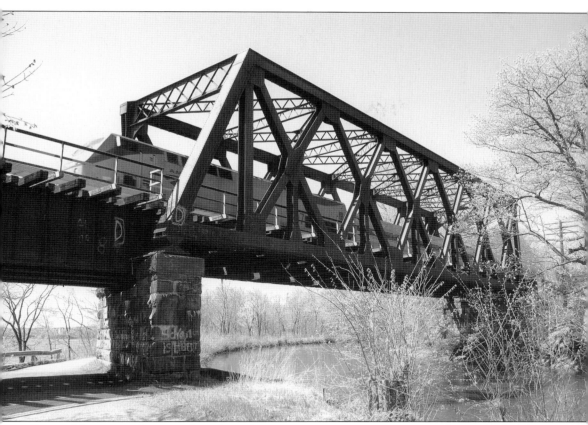

Pictured here is a close-up of an Amtrak passenger train as it passes over the towpath. The photograph was taken in 2006 just north of the railroad bridge. Notice the pier supporting the bridge is made of brownstone. (JG.)

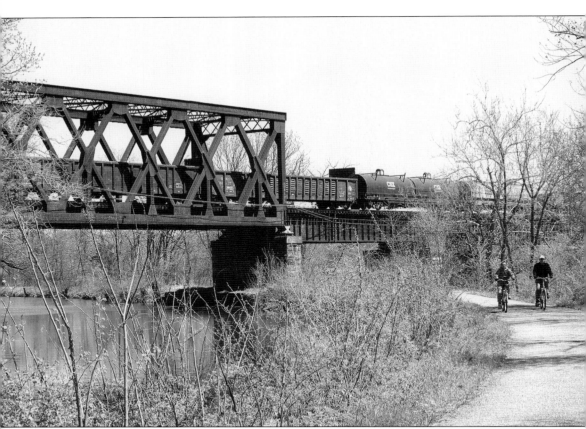

Here two cyclists roll south on the canal towpath as a freight train rumbles over the railroad bridge. The paved towpath is maintained by the Connecticut Department of Environmental Protection with the help of a nonprofit group, the Friends of the Windsor Locks Canal, and serves as an excellent walking, running, and bicycling trail. (JG.)

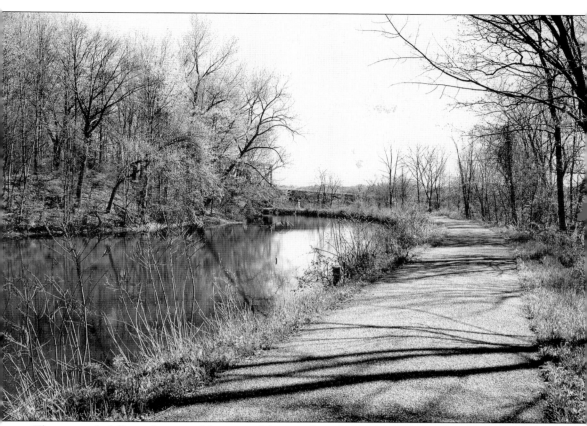

The towpath follows the graceful curve of the canal in this 2006 photograph taken just south of the railroad bridge. The towpath was the state's first bikeway to be established along the Connecticut River. The canal trail is open to visitors from April to November. From November until the end of March, the trail is closed to protect the wintering eagles that roost along this stretch of the river. (JG.)

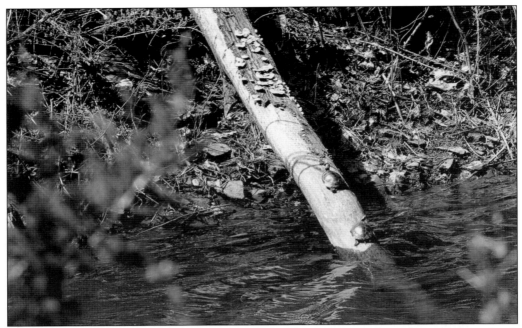

This pair of turtles was photographed as they sunned themselves on a log lying on the west bank of the canal. The canal is home to a diversity of animal life, including osprey, eagles, otters, herons, and many songbirds. (JG.)

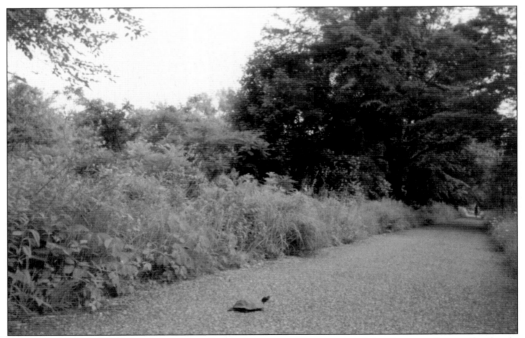

While bicycling early one morning, the author was able to snap this picture of a turtle slowly making its way across the towpath toward the canal. She has also encountered deer, great blue heron, and a family of wild turkeys on the path.

Another view of the towpath is shown here. On the right of this picture, the bank slopes down 30 feet to the river. Birch, sycamore, and cottonwood are among the many species of trees that grow on the riverbank.

The canal is also lovely in winter, as this 2003 scene of a snow-covered canal demonstrates. (MR.)

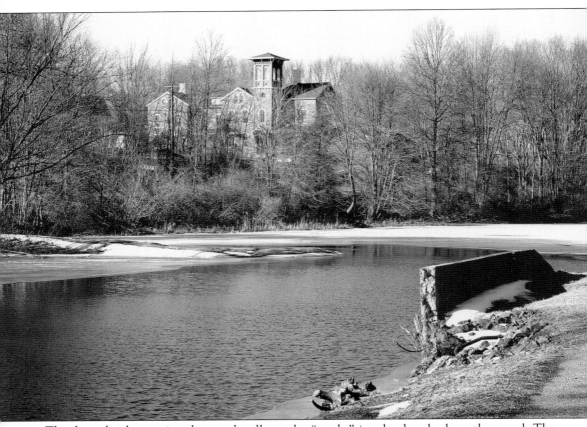

This large brick mansion, known locally as the "castle," is a landmark along the canal. The current owners have recently restored the 26-room house. (JG.)

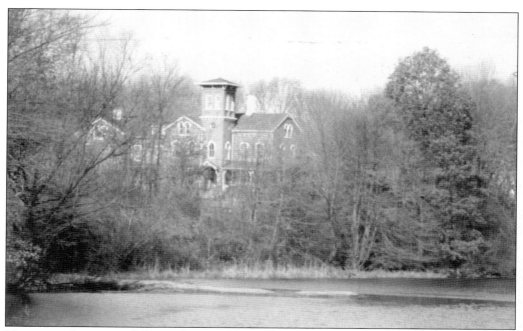

Here is another view of the castle. Note the tower on the side of the house. During the 19th century, the castle's original owner would go up to the lookout on top of the tower to view the boats coming down the canal. (MR.)

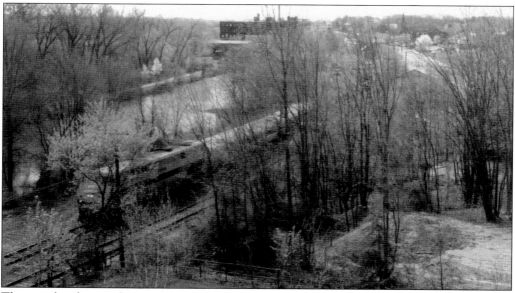

This overhead view shows a northbound train traveling next to the canal. In the distance, the Montgomery mill as well as buildings on Main Street in Windsor Locks can be seen. This photograph was taken in early spring 2006 from the top of the castle's tower—a great vantage point from which to view the area. (MR.)

This snow-covered canal bank was photographed near the southern (Windsor Locks) entrance to the canal trail in 2003. It is hard to believe that in a few short months the snow will be replaced by the white bracts of flowering dogwood. (MR.)

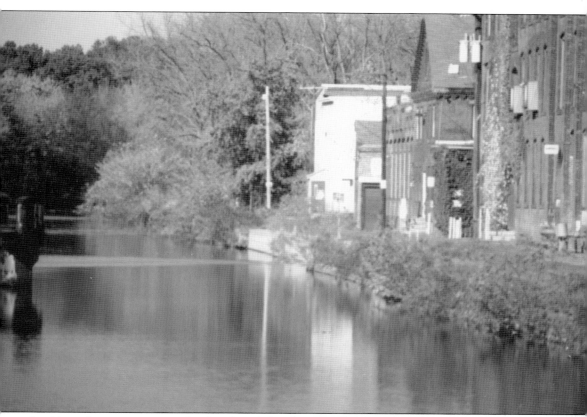

In this early-autumn scene, the facades of abandoned mills are reflected in the placid surface of the canal. This photograph was taken in 2000 near the southern entrance to the canal trail. (MR.)

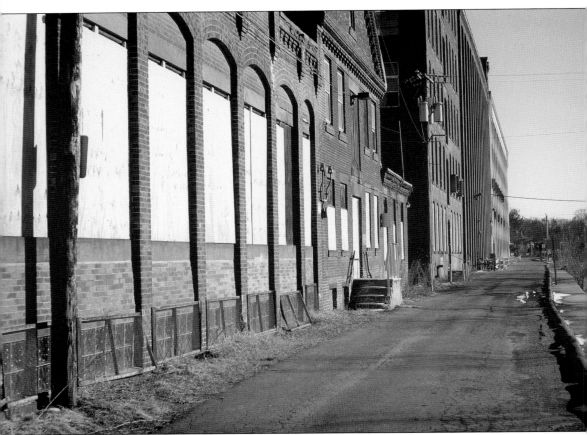

This photograph, taken in early 2006, shows the ornamental brick trim on the facades of the old mills that were located just south of the Windsor Locks (southern) entrance to the canal trail. In July 2006, a fire destroyed the historically significant Eli Horton and Son mill (the building in the foreground), which was the oldest surviving mill on the canal bank. Also lost in the blaze were several small machine shops where ball and cap muskets were made for the Union army during the Civil War. (JG.)

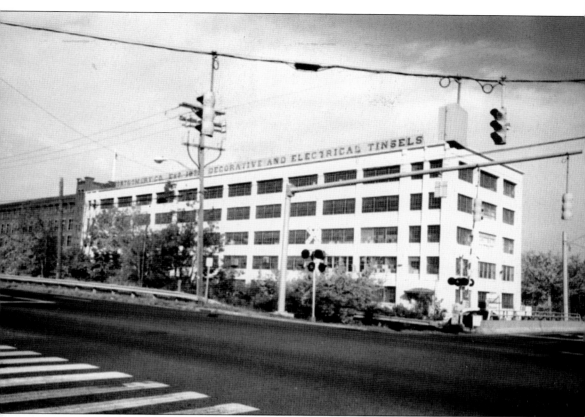

The former Montgomery Company buildings dominate Windsor Locks' Main Street in this 2004 image. The sign on top of the building reads, "The Montgomery Co. Est. 1871 Decorative and Electrical Tinsels." In 1920, the Montgomery Company purchased the Anchor Mills Paper Company building. It razed the existing structure and replaced it with the white reinforced concrete building that stands next to its older brick factory. The Montgomery Company continued in operation in Windsor Locks until 1989.

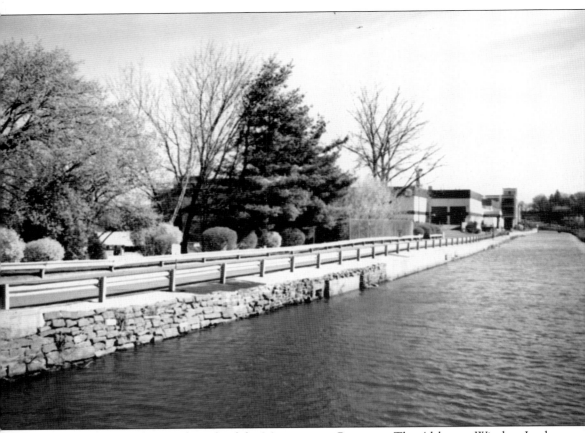

This view shows the canal south of the Montgomery Company. The Ahlstrom-Windsor Locks (formerly Dexter) plant can be seen in the distance. Notice the stone walls of the canal. The canal's sides were made of stone masonry to withstand the backwash from steamboats. (MR.)

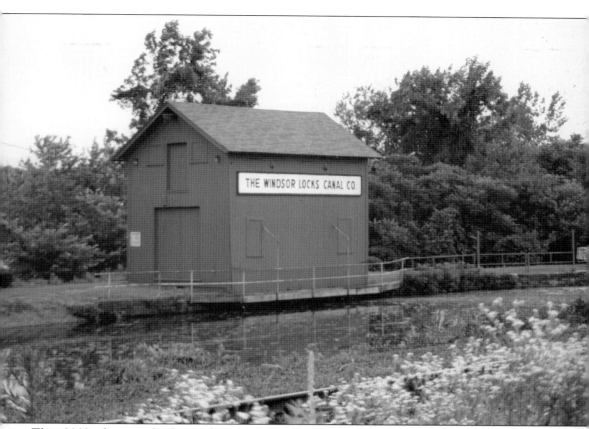

This 2002 photograph shows the wooden valve house located at the lower end of the canal. (MR.)

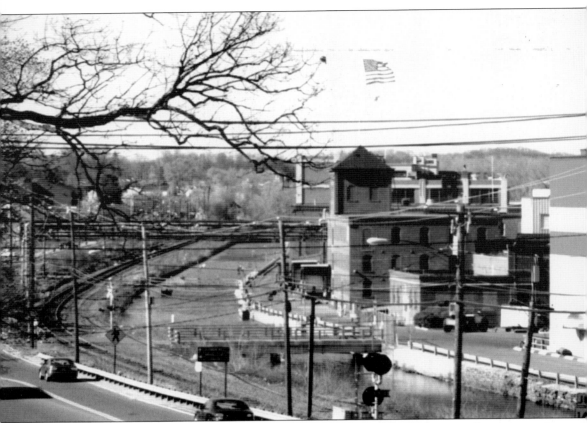

Although the image reproduced here is in black and white, the canal was a vibrant turquoise when this snapshot was taken during the late afternoon in the spring of 2006. The Windsor Locks Canal is closed to navigation, but it is still in use as a power and process waterway. (MR.)

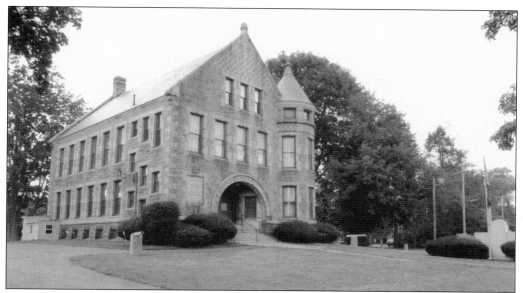

This photograph from 1997 shows Soldiers Memorial Hall in Windsor Locks. Completed in 1891, the stately granite building originally served as a meeting place for the Converse Post, No. 67, Grand Army of the Republic. After World War II, the building was made available to all veterans organizations. Today Soldiers Memorial Hall serves as the setting for all town activities honoring residents' wartime service. (DRC, Connecticut Historic Preservation Collection.)

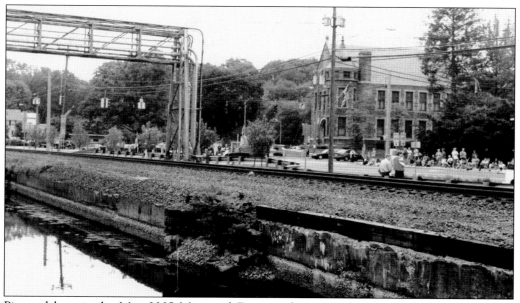

Pictured here is the May 2005 Memorial Day parade in Windsor Locks. Soldiers Memorial Hall can be seen in the background. An example of the Richardsonian Romanesque style of architecture, Soldiers Memorial Hall has several distinctive architectural features, including quoins, a round-arched recessed entryway, a conical-roofed tower, and stone finials. Checkerboard banding of light and dark granite appears below the top story of the tower and in the front gable. (MR.)

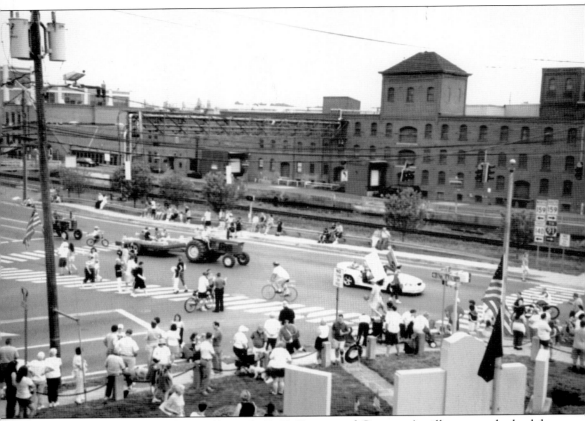

The canal and the Ahlstrom (formerly C. H. Dexter and Company) mill serve as the backdrop for the 2005 Memorial Day parade. Markers bearing the names of Windsor Locks residents who have died in wartime service since 1914 are in the foreground. (MR.)

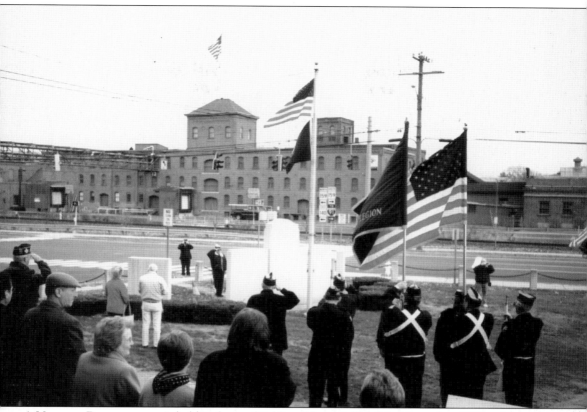

A Veterans Day ceremony is held in front of Soldiers Memorial Hall in November 2005 to honor the sacrifice of town residents who have died in wartime service. (MR.)

ACROSS AMERICA, PEOPLE ARE DISCOVERING SOMETHING WONDERFUL. *THEIR HERITAGE.*

Arcadia Publishing is the leading local history publisher in the United States. With more than 3,000 titles in print and hundreds of new titles released every year, Arcadia has extensive specialized experience chronicling the history of communities and celebrating America's hidden stories, bringing to life the people, places, and events from the past. To discover the history of other communities across the nation, please visit:

www.arcadiapublishing.com

Customized search tools allow you to find regional history books about the town where you grew up, the cities where your friends and family live, the town where your parents met, or even that retirement spot you've been dreaming about.